Wildlife Photographer
of the Year
Portfolio

WILDLIFE PHOTOGRAPHER
OF THE YEAR

Portfolio 28

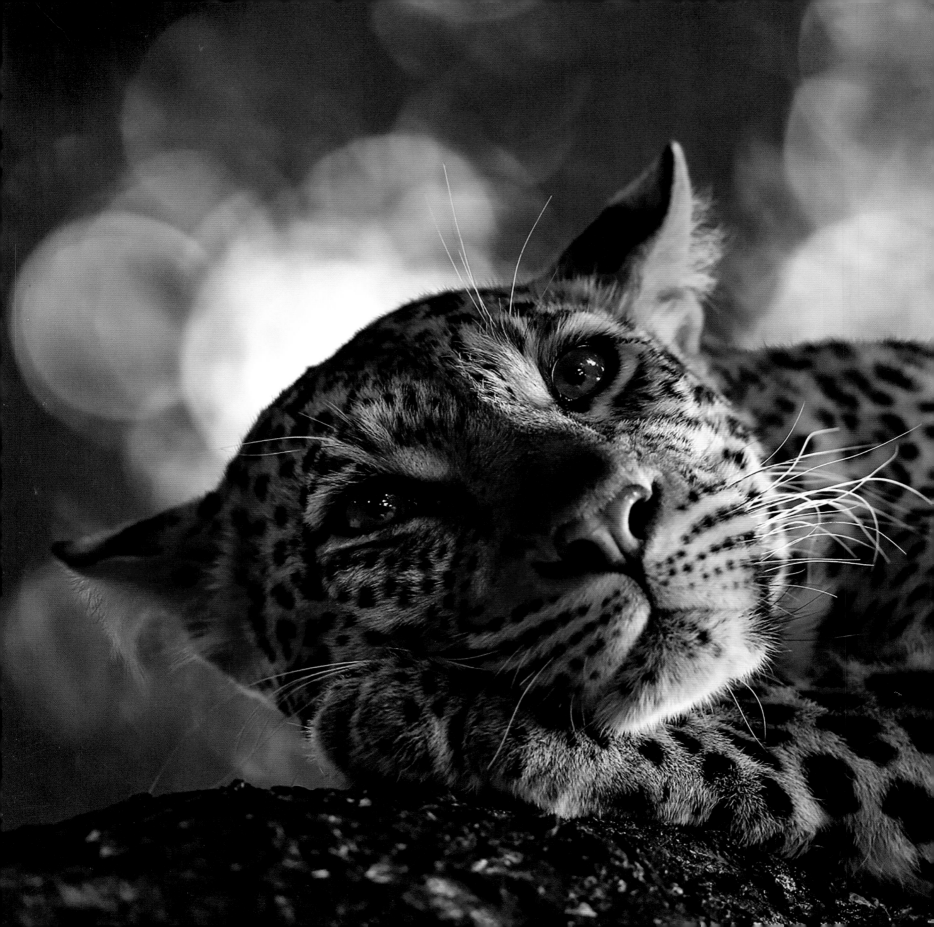

WILDLIFE PHOTOGRAPHER
OF THE YEAR

Portfolio 28

Published by the Natural History Museum, London

First published by the Natural History Museum,
Cromwell Road, London SW7 5BD

ISBN 978 0 565 0 94287

Editor Rosamund Kidman Cox
Designer Bobby Birchall, Bobby&Co Design
Caption writers Tamsin Constable, Tor McIntosh
and Jane Wisbey
Image grading Stephen Johnson
www.copyrightimage.com
Colour proofing Saxon Digital Services UK
Printing Printer Trento Sri, Italy

Right Zorica Kovacevic
Previous page Skye Meaker
Foreword page Sergey Gorshkov
Competition page Jan van der Greef

Contents

Foreword

What makes some images better than others? Some are better, of course, or there would be no basis for a competition, but how do you decide?

There is no formula and no simple answer. For the judges, it is more like a search for gems, for precious photographic moments or stories. It is exciting but also a great responsibility. Selecting just 100 images while discarding possibly 45,000 is done in the knowledge that winning in this, the world's largest natural history competition of any kind, can transform a photographer's life. Winning in Wildlife Photographer of the Year gives recognition and fortitude to a photographer to continue with a demanding profession – one with rewards that are generally more emotional than financial.

There is a certain structure to the selection process. It is provided by the categories, chosen to represent a range of subjects that reflect the ways we see and interact with the natural world. Within the structures, the gems the judges are looking for mainly concern originality, not so much of the subject but the viewpoint. (Indeed, there are many familiar subjects that have never been photographed in anything but a very ordinary way and still await a thoughtful, creative photographer.)

Beyond originality, what influences a decision can be as much an emotional reaction to a picture as an intellectual judgement. Surprise can give an initial advantage, but the immediate impact often wanes when you see the picture again. By comparison, pictures can grow on you as you explore the content – certainly when you have time to reflect and revisit. There is also the intangible element of a picture that is difficult to put into words but speaks to feelings and even memories. At the end of the process, there may be such a division of opinion over two pictures that another rises to the top through compromise.

There are also judging criteria beyond the visual effect of a photograph. First, there are ethical considerations. A picture can be discarded if there is any suspicion that an animal has been restrained or distressed. And strict attention is given to comparing submitted images in the finals with the camera's 'raw' unprocessed files (effectively the digital negatives) for any manipulation beyond processing and what is allowable in the rules.

Only after the judging, when the names of the photographers are finally revealed and the stories behind the pictures gathered together is it possible to assess what the whole represents. This year, for example, it became apparent that we had more female photographers in the roll-call than ever before. And just as heartening, among the young photographers, previous winners were showing up again as they rose through the age ranks.

Sometimes technical innovations lead to fresh perspectives – images that, in the past, would have been impossible or difficult to take. For the first time, images taken from drones have featured in this year's competition, though the judges had to be mindful of the disturbance drones can cause if flown too low or in a restricted area. Camera-trap shots – shots that would be impossible to take in any other way, of animals going about their normal business – are now regularly in the finals. This year in particular they have given us impressive views of animals within the panoramas of their environments.

Of course, some of the very best are straight shots of behaviour – something this competition has always championed – resulting from a photographer investing time in understanding an animal and knowing where and when to capture that unforgettable shot. Storytelling also remains a strong element. You may not like some of the photojournalism shots, but then that may reflect a dislike of what they reveal about human behaviour.

However you feel about a picture, whether it is one you feel should have won or one you feel shouldn't have, you will be mirroring the judges' discussions – and those of other viewers – about what qualifies as the best of the best. And passing judgement is, of course, part of the enjoyment.

This year's overall award-winner is in one sense traditional – a portrait. But what a striking one, and what magical animals. It is a picture you linger over – a symbolic reminder of the beauty of nature and how impoverished we are becoming as nature is diminished. It is an artwork worthy of hanging in any gallery in the world.

Rosamund Kidman Cox
Chair of the Jury, Wildlife Photographer of the Year 2018

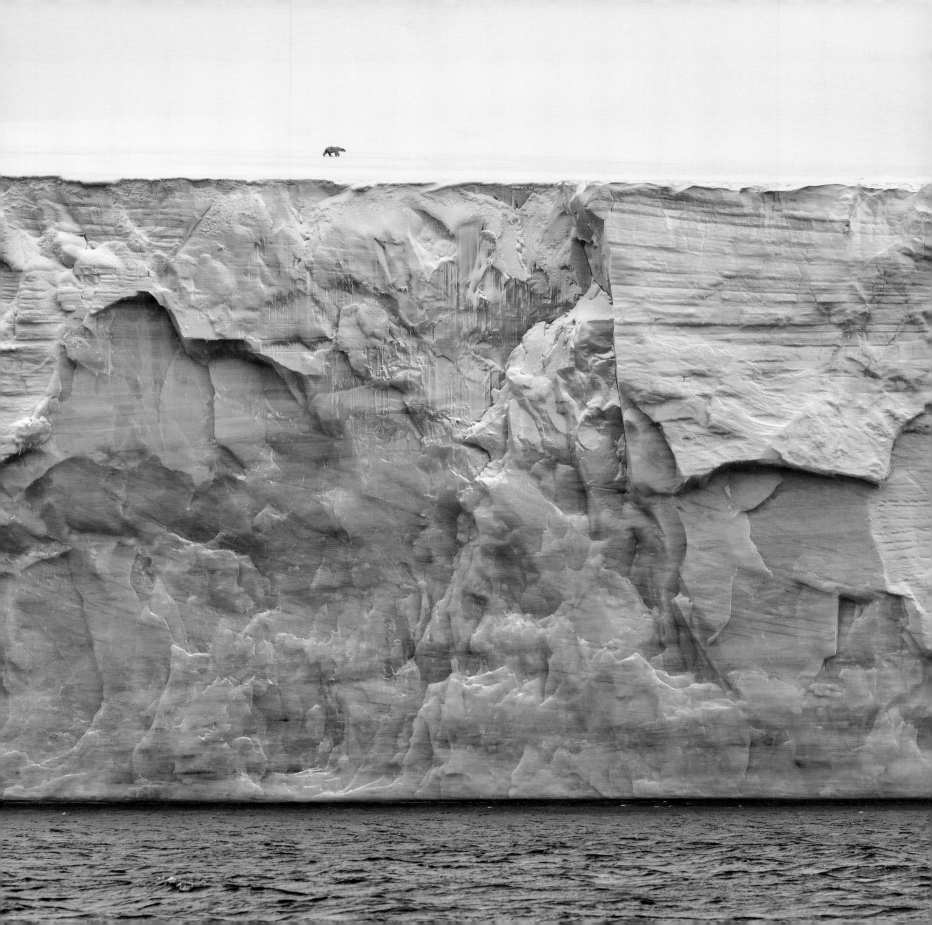

The Competition

Wildlife Photographer of the Year is much more than a competition. It is a showcase for the world's best pictures of wildlife. It provides both an inspiring annual catalogue of the wonders of nature and a thought-provoking look at our complex relationship with the natural world. It acts as a forum for all aspects of wildlife photography, and it provides a meeting place for practitioners. It also continues, after more than 50 years, to chart the progression of nature photography, whether new ways of seeing wildlife or new techniques for capturing intimate or revealing moments.

Anyone anywhere in the world can enter the competition – professional or not, old or young. To give the greatest scope for entries, it offers 16 categories, including ones for portfolio collections and for photo stories, reflecting the full range of nature and conservation subjects and all the genres, including black and white and underwater photography. For those 17 and under, there is a dedicated part of the competition – the Young Wildlife Photographer of the Year. It's there specifically to encourage the wildlife photographers of the future. Some of the top photographers today were young winners in the past.

All the winners are brought together from all over the world to attend the major awards celebration and the exhibition opening at the Natural History Museum in London. Their images also receive the greatest possible coverage, through the national and international travelling exhibition, the book and its translations and the extensive worldwide publicity – a combined reach of more than a billion people.

This year, the competition received 45,028 entries from 95 countries. That's a massive number for any jury to distil to just 100 pictures. So judging requires two extensive sessions, one lasting two weeks, whittling down the numbers to about 5,000, and the second lasting a week, when the judges gather at the Natural History Museum to review the final selection. The choices are made without the jury knowing the identity or nationality of the entrants, or the full background stories that you will read here. Each picture has to speak for itself.

The judges are looking for artistry and for fresh ways of seeing nature. Great emphasis is placed on subjects being wild and free, and on truth to nature, which is why there are strict rules on digital manipulation. But then most of the entrants and certainly most of the winners have a genuine love of nature and care deeply about the welfare and conservation of their subjects. And it's that – this community of like-minded people – which makes the competition so special.

The next Wildlife Photographer of the Year competition opens on 22 October and closes on 13 December 2018. For the categories and rules, see www.wildlifephotographeroftheyear.com

Judges

Alexander Badyaev (Russia/USA), biologist and wildlife photographer
Clay Bolt (USA), natural history and conservation photographer
Ruth Eichhorn (Germany), photo editor and curator
Angel Fitor (Spain), naturalist and underwater photographer
Sandesh Kadur (India), wildlife photojournalist and film-maker
Ian Owens (UK), Director of Science at the Natural History Museum
CHAIR
Rosamund 'Roz' Kidman Cox (UK), writer and editor

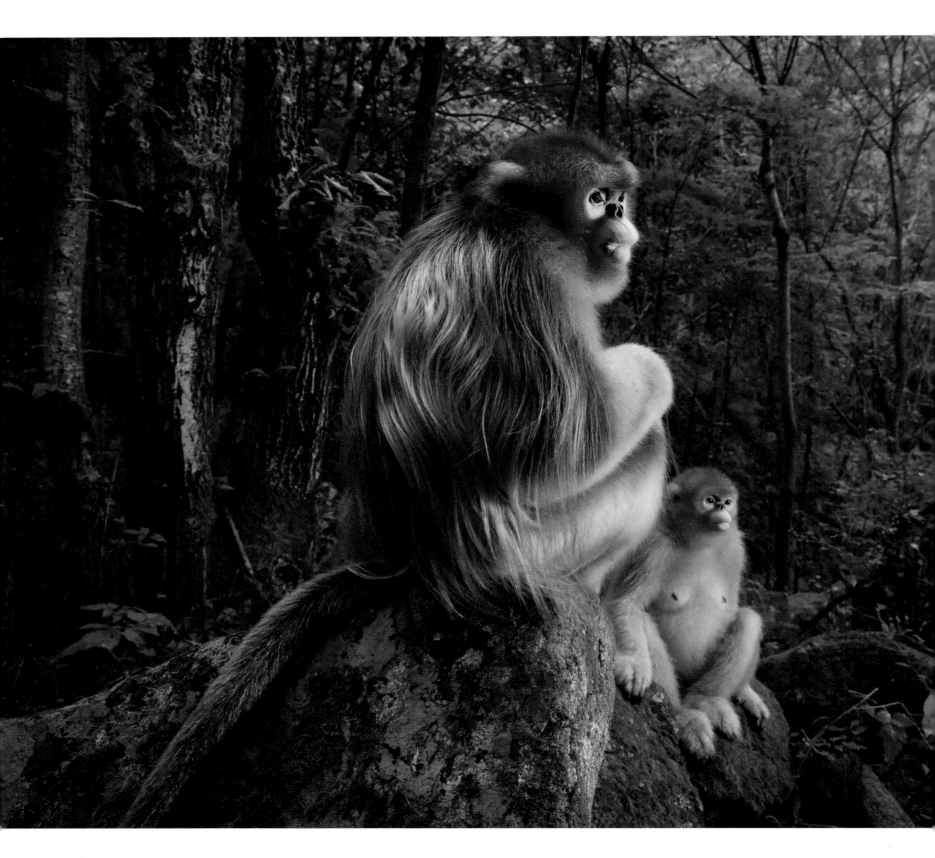

The Wildlife Photographer of the Year 2018

The Wildlife Photographer of the Year 2018 is Marsel van Oosten, whose picture has been chosen as the most striking and memorable of all the entries in the competition.

Marsel van Oosten

THE NETHERLANDS

A training in art and design led to a successful career as an art director, but a love of wildlife and a passion for photography finally took him from life in the fast lane to the challenges of survival as a nature photographer. Exhibited and published worldwide, Marsel has already won many awards and runs his own nature-photography tours.

WINNER

The golden couple

A male Qinling golden snub-nosed monkey rests briefly on a stone seat. He has been joined by a female from his small group. Both are watching intently as an altercation takes place down the valley between the lead males of two other groups in the 50-strong troop. It's spring in the temperate forest of China's Qinling Mountains, the only place where these endangered monkeys live. They spend most of the day foraging in the trees, eating a mix of leaves, buds, seeds, bark and lichen, depending on the season. Though they are accustomed to researchers observing them, they are also constantly on the move, and as Marsel couldn't swing through the trees, the steep slopes and mountain gorges proved challenging. Whenever he did catch up and if the monkeys were on the ground, the light was seldom right. Also, the only way to show both a male's beautiful pelage and his striking blue face was to shoot at an angle from the back. That became Marsel's goal. It took many days to understand the group's dynamics and predict what might happen next, but finally his perseverance paid off with this gift of a perfect situation, with a perfect forest backdrop and perfect light filtering through the canopy. A low flash brought out the glow of the male's golden locks to complete the perfect portrait. (See also page 60.)

Nikon D810 + Tamron 24–70mm f2.8 lens at 24mm; 1/320 sec at f8; ISO 1600; Nikon SB-910 flash.

Wildlife Photographer Portfolio Award

Javier Aznar González de Rueda

SPAIN

Javier is a biologist and wildlife photographer with a passion for the world's little-known smaller creatures. A member of the International League of Conservation Photographers (iLCP), he believes in the power of photography to help learning and conservation. Javier often works at night, when many of his subjects are most active, photographing them in their natural surroundings, while taking care not to disturb them. This portfolio is the result of a year in the Ecuadorian Amazon and in cloud forest observing treehoppers.

Bee on guard

The feisty stingless bee confronted Javier head on, beating its wings rapidly to warn him off. Javier was familiar with ants tending treehopper nymphs, but he had never before seen a bee acting as their protector. He returned to the spot, in Napo in the Ecuadorian Amazon, for several consecutive days, keen to document this lesser-known relationship. 'Sometimes, just one bee would be guarding the nymphs,' says Javier, 'though once, there were eight or more.' As well as buzzing aggressively with their wings, the bees flew protectively over their charges. In return for their diligence, they were treated to nutritious drops of honeydew produced by the nymphs. The bees were so active that it was a challenge to capture their behaviour, while keeping the nymphs in focus. Javier's patience was rewarded in this face-off – a bee with wings abuzz, painting rainbows in their wake, and the nymphs safely lined up beneath.

Canon EOS 5D Mark II + 65mm f2.8 lens; 1/160 sec at f13; ISO 800; Yongnuo + Nikon flashes; Sirui tripod + Uniqball head.

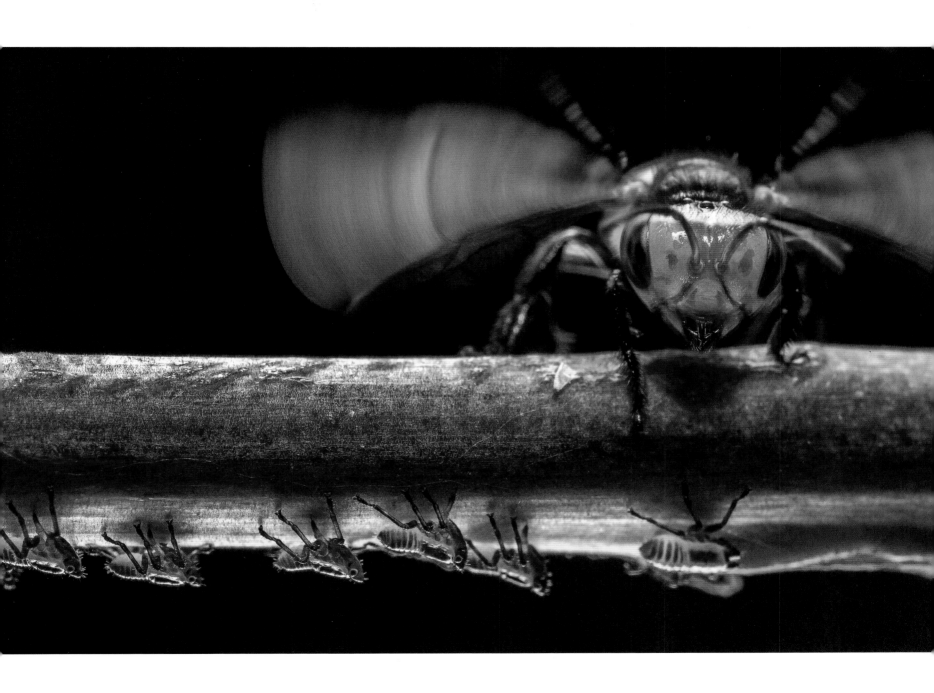

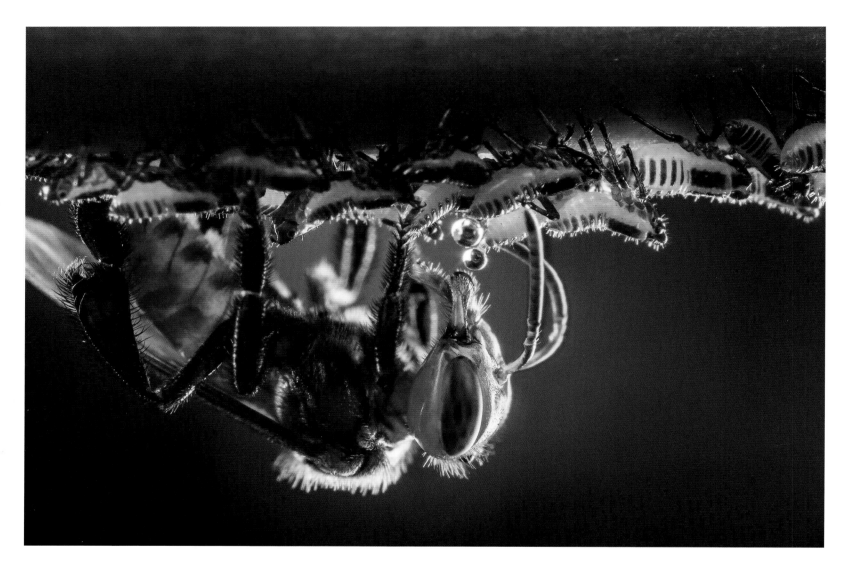

Sugar on tap

In an Ecuadorian cloud forest, a stingless bee gently taps a treehopper nymph to collect droplets of sugary honeydew. The treehoppers feed on plant sap and excrete any excess as a sweet liquid. This carbohydrate-rich secretion is so delicious to the bees that they seek to keep their personal supply secure. In return for sustenance, they protect the treehoppers from predators and reduce the risk of harmful fungal growth by cleaning up excess honeydew. But rather than waiting patiently to be fed, the bees elicit their own drinks. Javier describes how: 'When a bee touched a nymph on the back of the abdomen with its antennae, the nymph released a droplet of honeydew, which the bee sucked up.' It took several days for Javier to capture this precise moment – a behaviour rarely observed in such detail – telling the intricate but easily overlooked story of this mutual relationship.

Canon EOS 5D Mark II + 65mm f2.8 lens; 1/160 sec at f14; ISO 640; Yongnuo + Nikon flashes; Sirui tripod + Uniqball head.

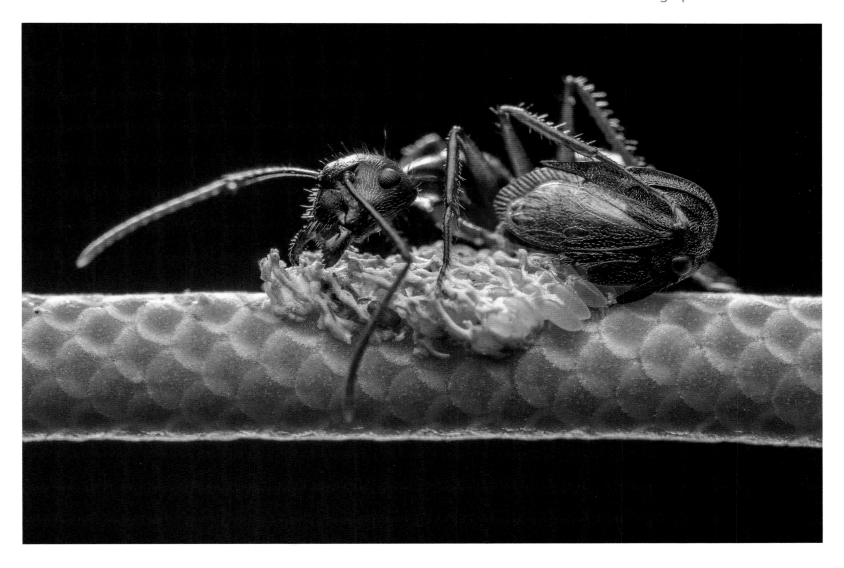

The odd couple

The tiny *Erechtia* treehopper (right) makes a very caring mother. She lays her eggs on a flower stem, covers them with a waxy secretion to protect them against desiccation, predators, parasitoids and fungi, and then stands guard over the clutch. Just 3 millimetres (an eighth of an inch) long, with a distinctive helmet extending along her thorax, she enlists the help of a large ant (left) with fearsome jaws to see off any threats. Ants are well known for forming mutually beneficial relationships with treehoppers. In exchange for its guard and cleaning duties, the ant receives nutritious honeydew from the treehopper. 'I noticed that an individual ant would look after a particular treehopper,' says Javier. At such a high magnification, the depth of field (amount in focus) was very narrow. 'It took me a few days', he says, 'to capture the ant's head and the treehopper aligned in the same plane' and therefore in focus.

Canon EOS 5D Mark II + 65mm f2.8 lens; 1/100 sec at f10; ISO 640; Yongnuo + Nikon flashes; Sirui tripod + Uniqball head.

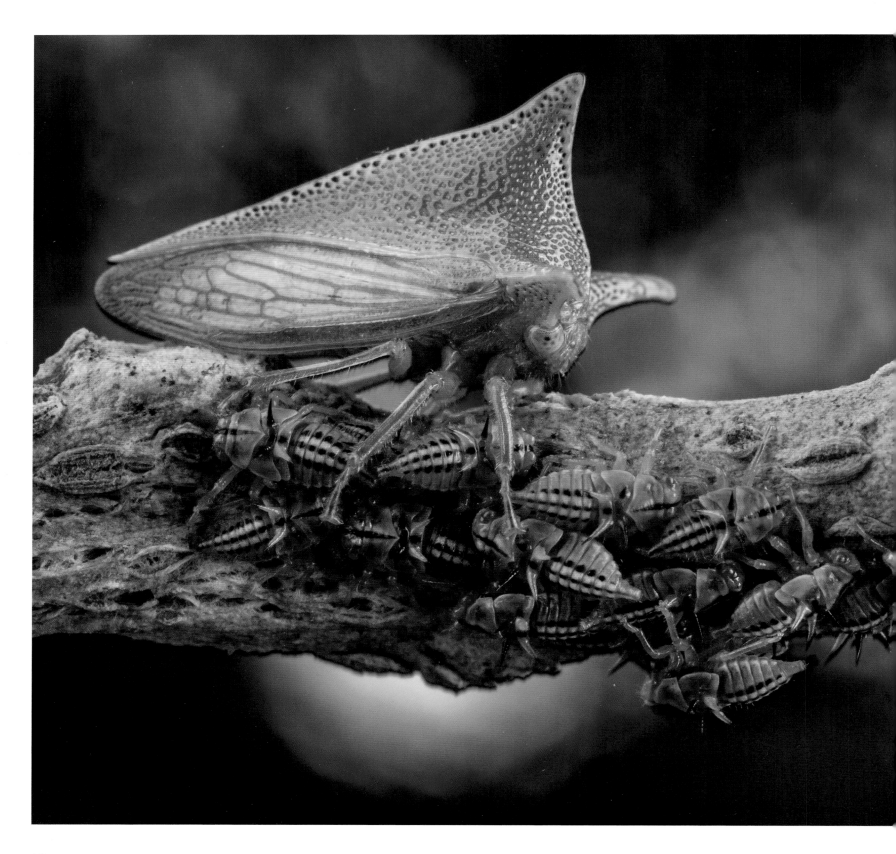

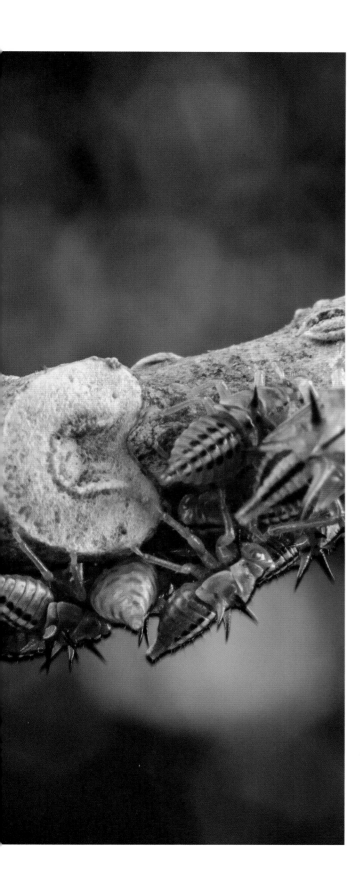

Mother defender

A large *Alchisme* treehopper guards her family as the nymphs feed on the stem of a nightshade plant in El Jardín de los Sueños reserve in Ecuador. Unlike many treehoppers, which enlist the help of other insects (mostly ants), this species is guarded by the mother alone. She lays her eggs on the underside of a nightshade leaf, covers them with a thin secretion and then shields the clutch with her tiny frame. Once the eggs hatch, they develop through five nymphal stages, differing in size, colour and ornamentation – the black stripes and little green spines indicate that these are late-stage nymphs, soon to moult into adult form. The devoted mother watches over them for the duration, twisting her body to wield the spines on her back at any attackers that she senses or is alerted to by her nymphs' vibrations or pheromones (chemicals acting like hormones). She occasionally accepts help from another treehopper, and may even leave it in charge for a while, but she stays with her family until they transform into adults.

Nikon D810 + 60mm f2.8 lens; 1/5 sec at f32; ISO 500; Quadralite Reporter flash; Sirui tripod + Uniqball head.

Rainforest relations

Two female *Metheisa* treehoppers watch over their eggs in Ecuador's El Jardín de los Sueños cloud-forest reserve. Before laying, each used its ovipositor – the rigid tube through which the clutch is laid – to carve a long incision in the plant stem, which now cradles the eggs. A couple of ants patrol the stem, ready to attack any predators or parasitoids that might threaten the small bugs. The ants' reward is the sweet honeydew that the mother treehoppers excrete after sucking up plant sap. Though the mother's mouthparts can pierce the stem to feed on plant sap, the nymphs can struggle to penetrate the plant's tough exterior, and so the mother cuts feeding slits to get them started. It is not unusual to find egg-guarding females so close to each other, perhaps because an aggregation of nymphs attracts more ant guards. Fascinated by the intricacies of the behaviours he observed, Javier chose a wide angle to reveal the tiny players absorbed in the duties of their small world.

Nikon D810 + Tokina 10–17mm f3.5–4.5 lens at 16mm; 1/15 sec at f32; ISO 800; Yongnuo flash; Sirui tripod + Uniqball head.

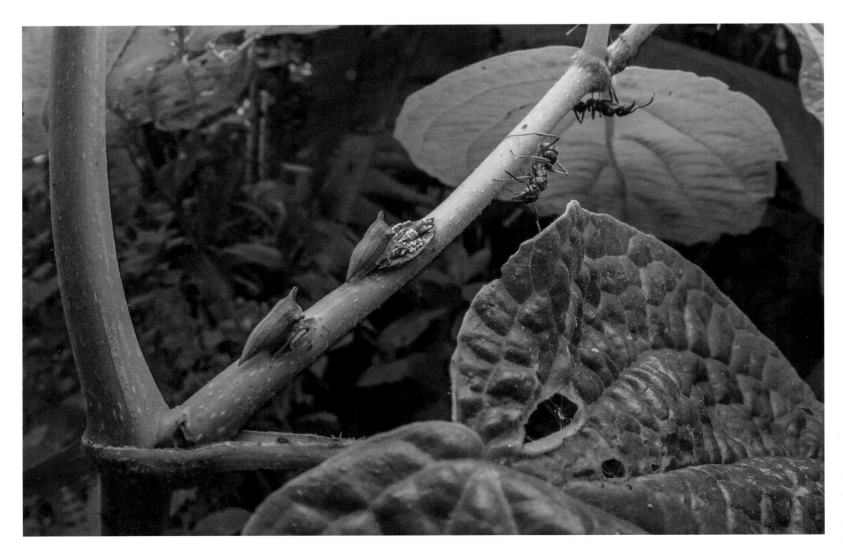

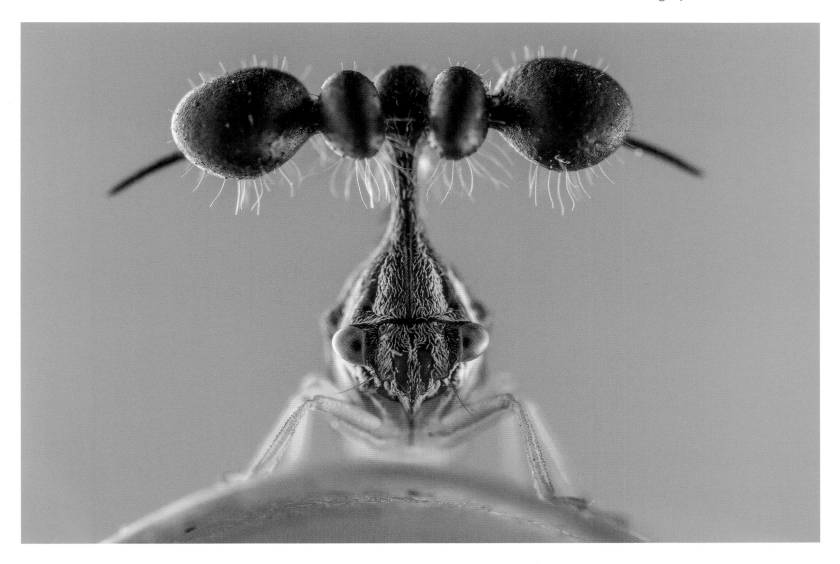

Little big head

The outlandish appearance of the *Bocydium* treehopper belies its shy nature. Javier found just two in the three months he spent looking for them in the Amazon – and the first flew away before he could photograph it. Nearly all treehoppers have enlarged thoracic structures, known as helmets, which develop from pairs of tiny wing-like forms that expand and fuse above the body. They are often cryptic in function, disguising the treehoppers as thorns or leaves to match their host plants. With such an eye-catching array of bristly, hollow spheres of chitin over its head, *Bocydium* cannot be trying to hide. The bristles suggest a possible sensory function, but it seems more likely that the aim is to deter predators, perhaps by mimicking an ant, by making the bearer difficult to swallow or by acting as a decoy (a predator might just bite off the helmet, leaving its prey to escape). Taking great care not to scare the small bug away, Javier captured its portrait head-on for maximum impact.

Canon EOS 70D + 65mm f2.8 lens; 1/200 sec at f7.1; ISO 100; Yongnuo + Quadralite Reporter flashes; Sirui tripod + Uniqball head.

Behaviour: Mammals

Kuhirwa mourns her baby

Ricardo Núñez Montero

SPAIN

Kuhirwa, a young female member of the Nkuringo mountain gorilla family in Uganda's Bwindi Impenetrable Forest, would not give up on her dead baby. What Ricardo first thought to be a bundle of roots turned out to be the tiny corpse. Forced by the low light to work with a wide aperture and a very narrow depth of field, he chose to focus on the body rather than Kuhirwa's face. Guides told him that she had given birth during bad weather and that the baby probably died of cold. At first Kuhirwa had cuddled and groomed the body, moving its legs and arms up and down and carrying it piggyback like the other mothers. Weeks later, she started to eat what was left of the corpse, behaviour that the guide had only ever seen once before. Kuhirwa's initial reactions to her bereavement echo responses to death seen in other species. From elephants stroking the bones of dead family members to dolphins who try to keep dead companions afloat, there is an abundance of credible evidence that many animals – ranging from primates and cetaceans to cats, dogs, rabbits, horses and some birds – behave in ways that visibly express grief, though individual reactions vary. Kuhirwa's behaviour can be understood as mourning, without the need to speculate about her thoughts.

Nikon D610 + 70–300mm f4.5–5.6 lens at 185mm; 1/750 sec at f5; ISO 2200.

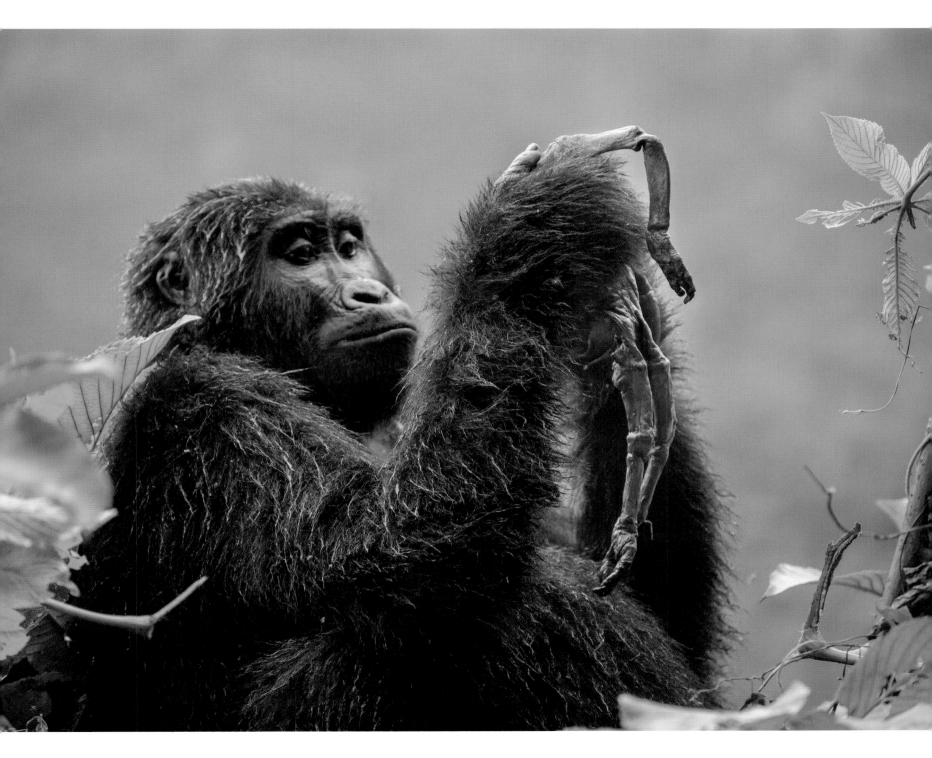

Ahead in the game

Nicholas Dyer

UK

A pair of African wild dog pups play a macabre game of tag with the head of a chacma baboon – the remains of their breakfast. The endangered African wild dog (aka the painted hunting dog) is best known for hunting antelopes, such as impalas and kudus. But over the past five years, in Mana Pools National Park, northern Zimbabwe, Nick has witnessed three different packs regularly killing and eating baboons – highly unusual, not least because baboons are capable of inflicting severe wounds. The hunting technique has been perfected by Blacktip, mother of the pups and the alpha female of the Nyakasanga pack. That morning, Nick had tracked a pack on foot for 3 kilometres (nearly 2 miles), taking in two failed impala hunts before the dogs finally seized a baboon. It wasn't enough to feed the whole pack, but it satisfied nine pups. They stopped short of the baboon's skull, and then the fun began. Nick, lying nearby, watched more than half an hour of chasing, tackling and tugs-of-war with the leftovers.

Nikon D5 + 400mm f2.8 lens; 1/640 sec at f5.6 (-0.6 e/v); ISO 800; Redged tripod + Wimberley head.

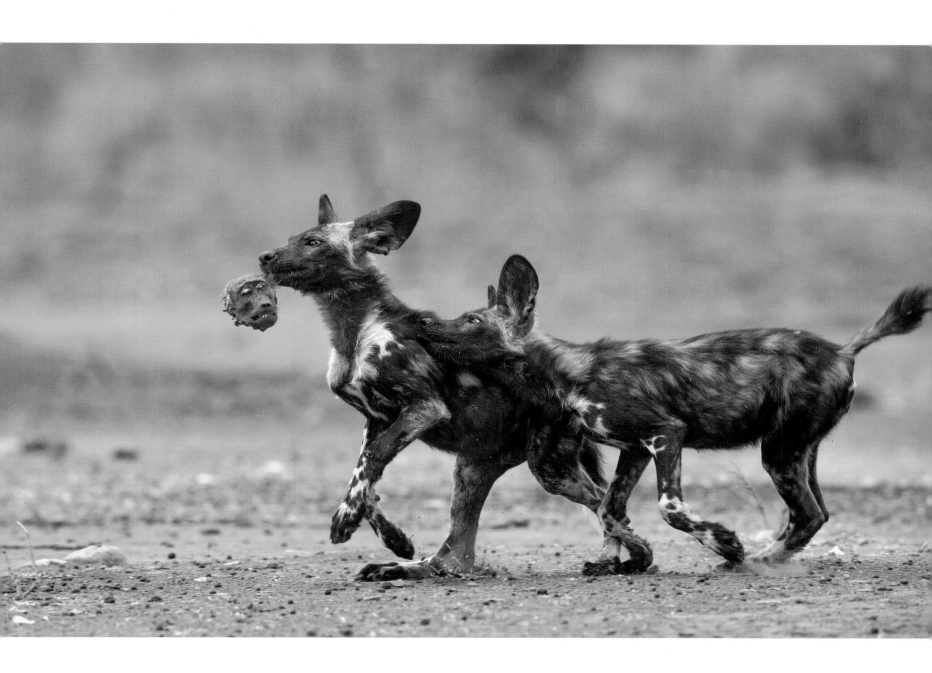

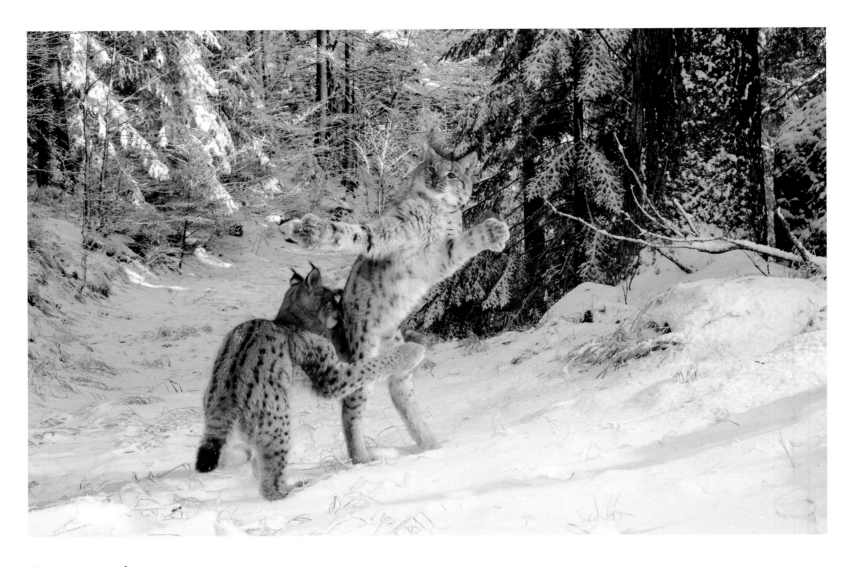

Kitten combat

Julius Kramer

GERMANY

It had been more than a year since Julius set up his camera trap in Germany's Upper Bavarian Forest, and he had got just two records of Eurasian lynx. He was on the brink of giving up when a biologist colleague insisted that this was 'such a typical spot for lynx'. Like many solitary cats, the males have expansive home ranges, within which one or more females live. Most active at dawn and dusk, they are powerfully built, with slightly longer hindlimbs for pouncing on prey. They hunt mainly herbivores, such as deer, which brings them into conflict with hunters. Julius went on to weather problems including failed batteries, humidity, deep snow and spider webs before his luck changed dramatically. Two six-month-old kittens turned up to play. Honing their hunting skills with joyful exuberance, they rewarded Julius with pictures and the hope that the population might be growing.

Nikon D3 + 28–80mm f3.3–5.6 lens at 38mm; 1/40 sec at f11; ISO 1250; two Nikon SB-28 flashes; Trailmaster trail monitor.

The meerkat mob
Tertius A Gous
SOUTH AFRICA

When an Anchieta's cobra reared its head and moved towards two meerkat pups near their warren on Namibia's Brandberg Mountain, the rest of the pack – foraging nearby – reacted almost instantly. Rushing back, the 20-strong group split into two: one group grabbed the pups and huddled a safe distance away, the other took on the snake. Fluffing up their coats, tails raised, the mob edged forwards, growling. When the snake lunged, they sprang back. This was repeated over and over for about 10 minutes. Tertius had a ringside seat from his vehicle and relished the chance to capture such intense interaction between the meerkat pack and the little known Anchieta's cobra. Focusing on the snake's classic profile and flicking tongue, he also caught the expressions of fear and aggression among the meerkats, some facing their attacker and one fleeing. Finally, the cobra gave up and disappeared down a burrow into the warren. The meerkats reunited and scurried away, most probably to an alternative – snake-free – warren in their territory.

Canon EOS-1D Mark IV + 500mm f4 lens; 1/1000 sec at f16; ISO 640.

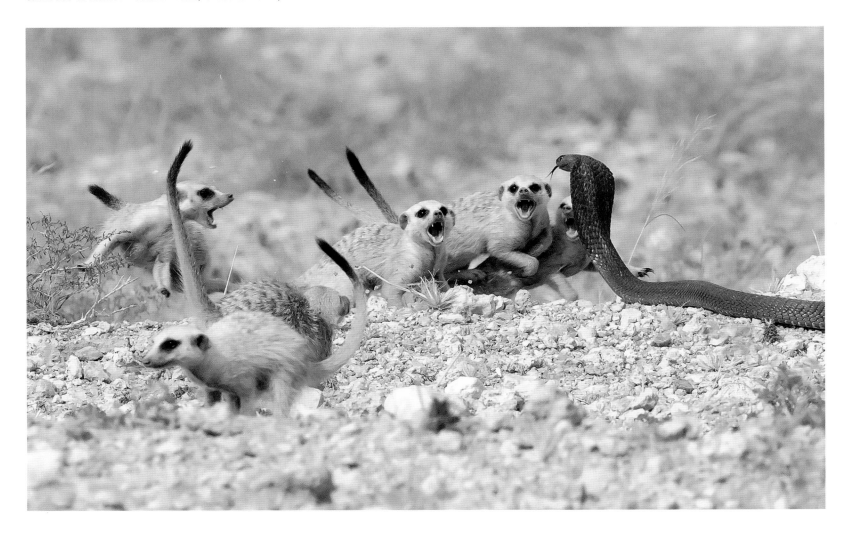

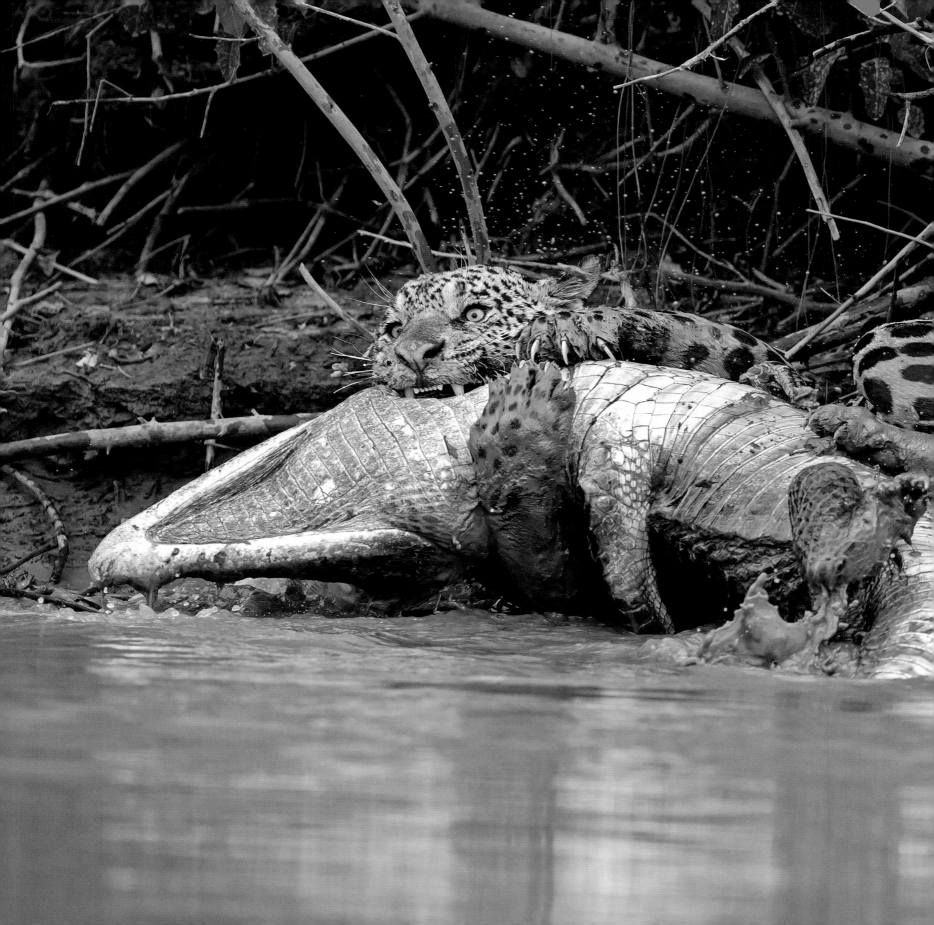

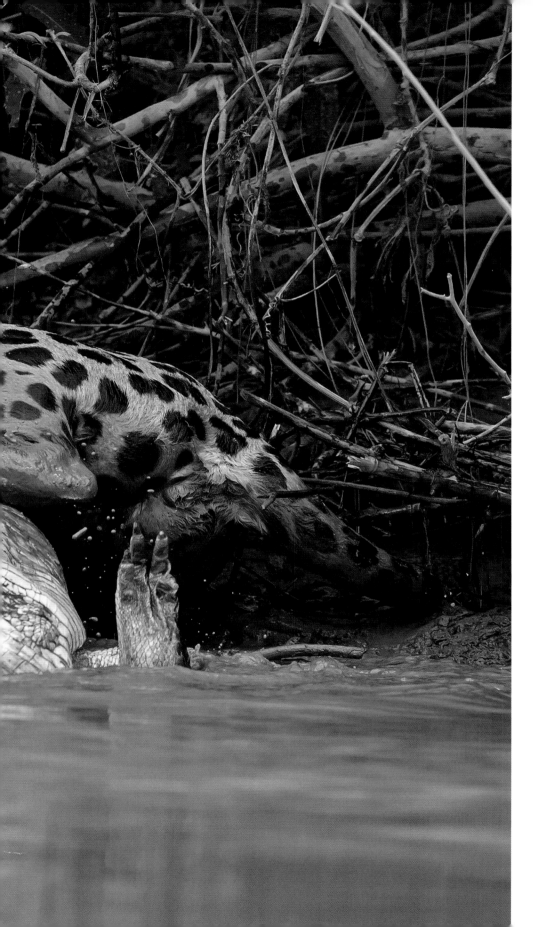

The bigger bite
Chris Brunskill
UK

From a small motorboat on a fast-flowing river in Brazil's northern Pantanal, Chris steadied his long lens on an epic struggle between two top predators – a female jaguar and a large yacaré caiman. He had seen jaguars hunt caiman before, only this time, he was gifted with a clear view, in good light. After a failed charge against some capybara, the jaguar had been making her way upriver when she stepped on the reptile hidden in the shallows and pounced. Caiman can escape the clutches of jaguars, but this young female had a good grip, with three legs wrapped around her writhing prey and teeth and claws embedded. Relative to its size, the jaguar has the most powerful bite of the big cats (thanks to robust canines and a large head) and is the only one that regularly kills by piercing the skull of its prey. The pair wrestled for several minutes at the water's edge, before the jaguar managed to inflict her trademark bite. She spent the next 20 minutes dragging the hefty carcass up the muddy riverbank and out of sight, reasserting her reputation as South America's most formidable predator.

Canon EOS-1D X Mark II + 400mm f2.8 lens; 1/2000 sec at f4; ISO 640.

Behaviour: Birds

Blood thirsty
Thomas P Peschak
GERMANY/SOUTH AFRICA

When rations run short on Wolf Island, in the remote northern Galápagos, the sharp-beaked ground finches become vampires. Their sitting targets are Nazca boobies and other large birds on the plateau. Boobies thrive here, nesting among dense cactus thickets and fishing in the surrounding ocean, but the finches have a tougher time. The island has no permanent water and little rainfall. The finches – among the species that inspired Darwin's theory of evolution – rely on a scant diet of seeds and insects, which regularly dries up. Pecking away at the base of booby flight feathers with their sharp beaks – a trait that may have evolved from feeding on the birds' parasites – they drink blood to survive. 'I've seen more than half a dozen finches drinking from a single Nazca booby,' says Tom. Rather than leave and expose their eggs and chicks to the sun, the boobies appear to tolerate the vampires, and the blood loss doesn't seem to cause permanent harm. Working on a climate-change story (the Galápagos may offer an early warning of the effects on biodiversity of global changes), Tom had secured a rare permit to land on the island. He made it up the steep cliffs, scrambling over loose rocks to reach the plateau. For maximum impact, he shot the bloody scene at bird's eye level to capture the one female feeding and another waiting just behind.

Nikon D5 + 16–35mm f4 lens; 1/200 sec at f20; ISO 160; Profoto B1X 500 AirTTL flash.

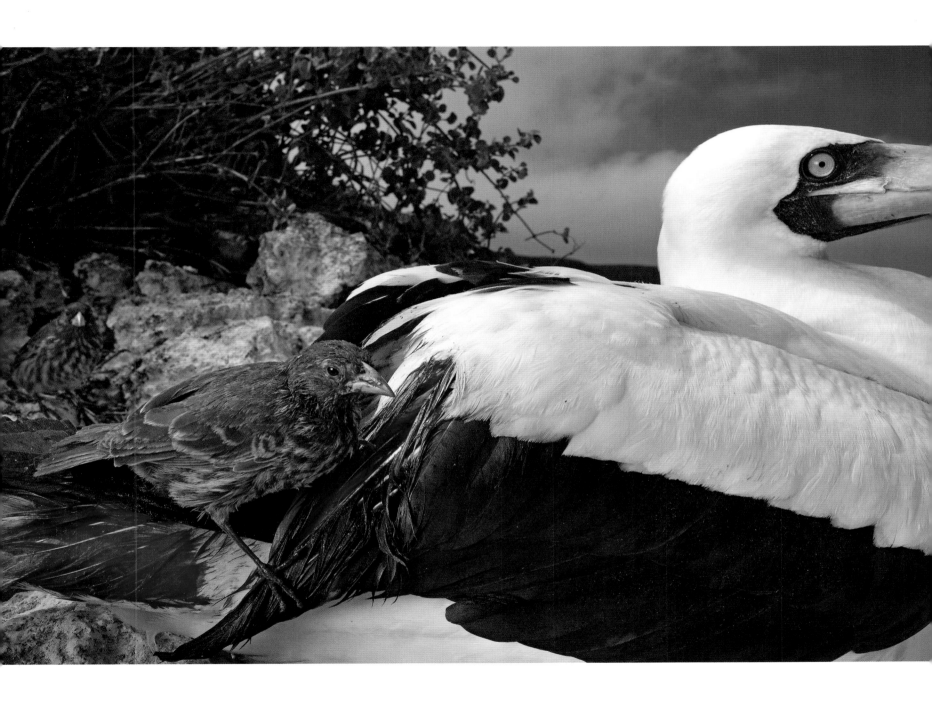

The antpecker
Oliver Richter
GERMANY

Every spring, Oliver eagerly awaits the return of Eurasian wrynecks from Africa to the open country near his home in Saxony, Germany. The wryneck – a species of woodpecker so called because of its defensive behaviour of twisting its head in the manner of a snake – nests in natural cavities in scrubland, old woods and orchards. 'I treasure these fragments of intact landscape, which are so ideal for these birds,' says Oliver. Like other woodpeckers, wrynecks have large heads and long tongues, but their shorter, more slender bills are better suited to gleaning ants from crevices than drilling holes in trees. Oliver set up his camera, camouflaged with grass, close to an ants' nest and then retreated to his car, where he could trigger it remotely. A pair of wrynecks – well camouflaged in mottled brown – began unearthing ants' cocooned pupae and then flying off to feed them to their hungry young in a tree-hole nearby. Using a wide angle to reveal the wryneck's habitat, Oliver captured the precise moment one bird retrieved a pupa on the tip of its sticky tongue.

Canon EOS 5D Mark III + 17–40mm f4 lens at 24mm; 1/1000 sec at f10; ISO 800; Yongnuo remote trigger.

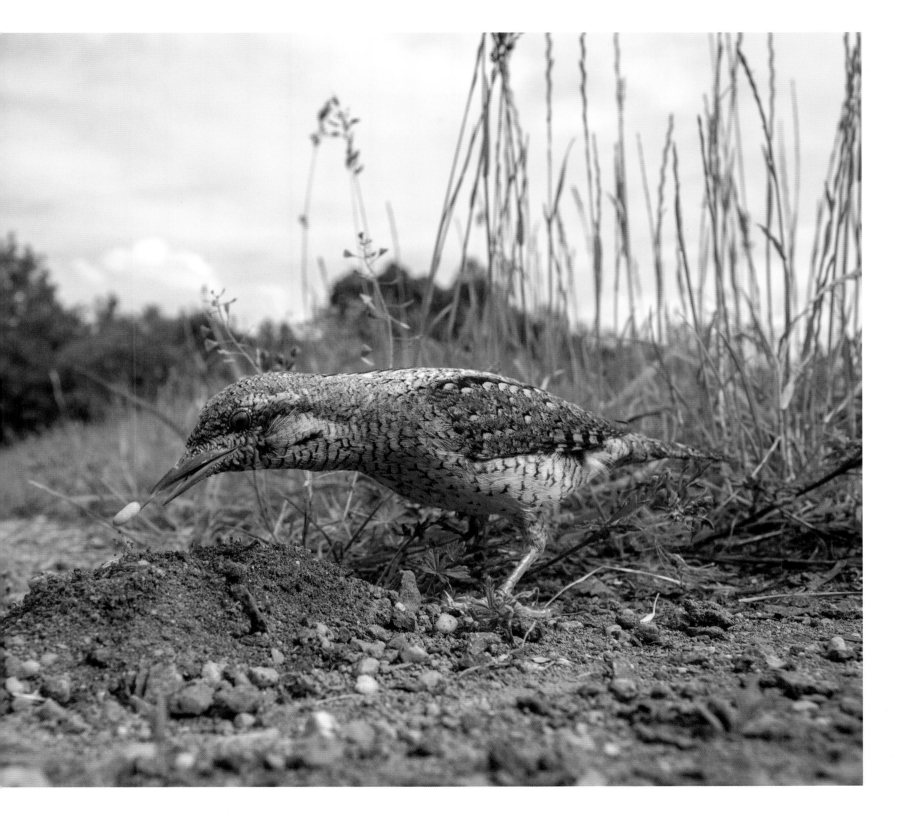

Togetherness
Karen Schuenemann
USA

It was late in the season to be nest-building, but this pair of western grebes was not about to give up. Their first nest, in San Joaquin Wildlife Sanctuary, California, had been raided by a raccoon, and so they were starting again. When Karen spotted them on her early morning walk, they were busily taking reeds from the edge of the pond to emergent vegetation near the shore, where they intended to anchor their floating nest. 'They were so absorbed in their work,' she says, 'they didn't seem to notice me.' Western grebes often nest in colonies, but this pair was alone – the others on the pond already had chicks. Grebes spend almost all their time on water, diving mainly for fish, which they spear or snap up with their long bills, taking larger prey to the surface before swallowing it. On land, their long-necked grace disappears, as their legs set far back on their bodies lead to a waddling gait. Karen took advantage of the overcast light to frame the elegant couple against the glassy water, capturing the dynamic reflections of the pair, intent on their task.

Nikon D5 + 500mm f4 lens; 1/1600 sec at f8 (+0.3 e/v); ISO 1000; Really Right Stuff monopod + ballhead.

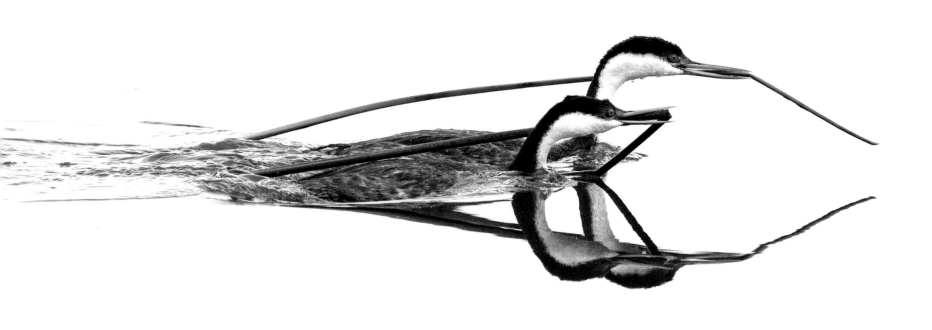

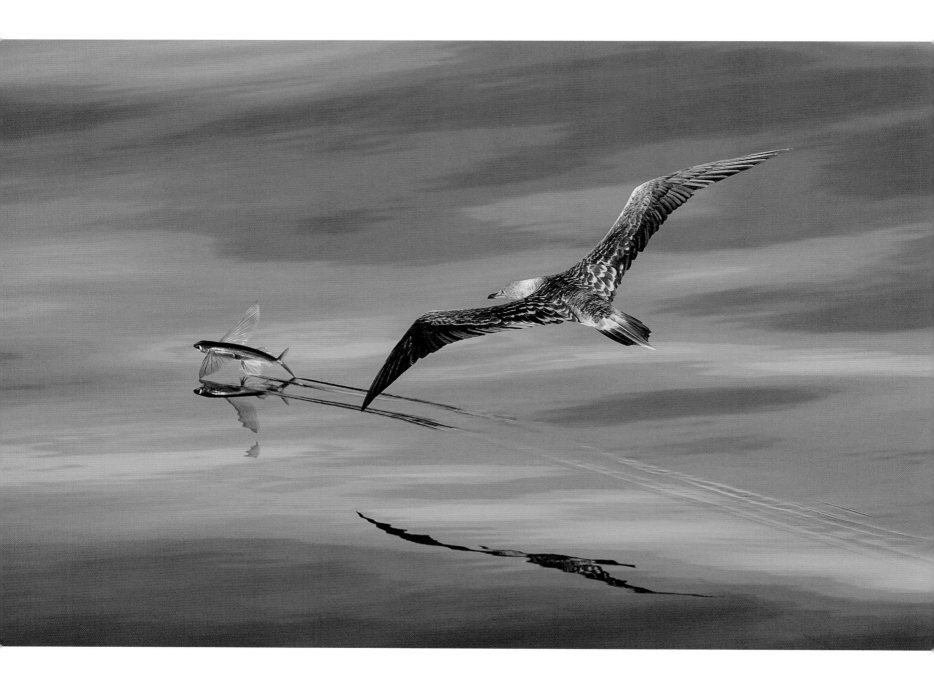

Flight

Sue Forbes

UK

For days, Sue scanned rough seas in the Indian Ocean. 'We'd often see flying fish,' she says, 'but only occasionally would there be boobies.' Then, one morning – northeast of D'Arros Island in the Outer Islands of the Seychelles – she awoke to find tranquil water and a single juvenile red-footed booby, circling. These ocean-going birds – the smallest booby species, with a metre-wide (3-foot) wingspan – spend most of their time at sea, flying long distances with ease. Sharp-eyed, they swoop down to seize prey, mainly squid and flying fish. Their bodies are streamlined for plunge-diving – nostrils closed and wings pinned back – and nimble enough to grab flying fish in mid-air. Before breaking the surface to escape predators such as tuna and marlin, flying fish build up tremendous speed under water, to glide, airborne, on their stiff pectoral fins. Sue kept her eye on the bird. She had no idea when and where a chase might happen. 'Suddenly, a fish leapt out', she says, 'and down came the booby.' With quick reactions, Sue captured the fleeting moment of the pursuit. The booby missed, and the fish got away.

Canon EOS 5D Mark III + 300mm f2.8 lens + 1.4x extender; 1/1600 sec at f9; ISO 640.

Fitting the bill

Jess Findlay

CANADA

A common loon offers its chick a damselfly nymph plucked from the mud in a lake in southern British Columbia, Canada. In North America, common loons (known in Europe as great northern divers) usually breed on large forest-fringed lakes. They feed mainly on fish, which they chase at high speed under water and often swallow before resurfacing. But a very young chick would struggle to eat even a tiny fish. So the parents lead their chicks (usually no more than two) into shallow water where they can feed on small aquatic insects plucked from vegetation or the lake bed. Within hours of hatching, the sooty black chicks are able to swim, though they often ride on their parents' backs. In this head-on view, Jess captured the parent's complete focus on its chick and the delicacy of the intimate moment.

Canon EOS 7D Mark II + 100–400mm f4.5–5.6 lens at 400mm; 1/250 sec at f5.6; ISO 1000.

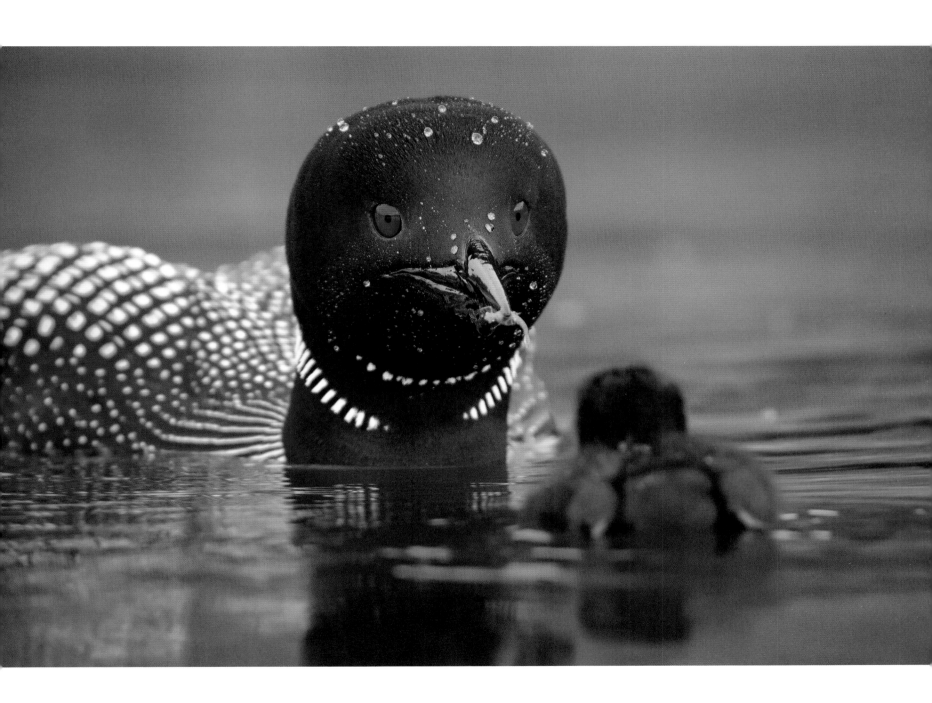

Behaviour:
Amphibians
and Reptiles

Hellbent
David Herasimtschuk
USA

It was not looking good for the northern water snake, clamped tightly in the jaws of a hungry hellbender, but it was a remarkable find for David. Drifting downstream in Tennessee's Tellico River, in search of freshwater life (as he had done for countless hours over the past seven years), he was thrilled to spot the mighty amphibian with its struggling prey. North America's largest aquatic salamander – up to 75 centimetres (29 inches) long – the hellbender has declined significantly because of habitat loss and degradation of the habitat that remains. Breathing primarily through its skin and seeking shelter and nest sites under loose rocks, it favours cool, flowing water in clear rocky creeks and rivers. Its presence indicates a healthy freshwater ecosystem. 'It looked as though the hellbender had a firm grip and the snake was tiring,' says David, 'but then the snake squeezed its powerful body against the hellbender's head.' When the attacker tried to reposition its bite, wrinkly folds of skin rippling, the snake pushed free from its jaws and escaped. The intense drama was over in just a few minutes, but with quick reactions, David captured this rarely seen behaviour, portraying the 'diabolic charisma' of the giant hidden just beneath the surface.

Sony a7R II + 28mm f2 lens + Nauticam WWL-1 lens; 1/60 sec at f13; ISO 1250; Nauticam housing; Inon Z-240 strobe.

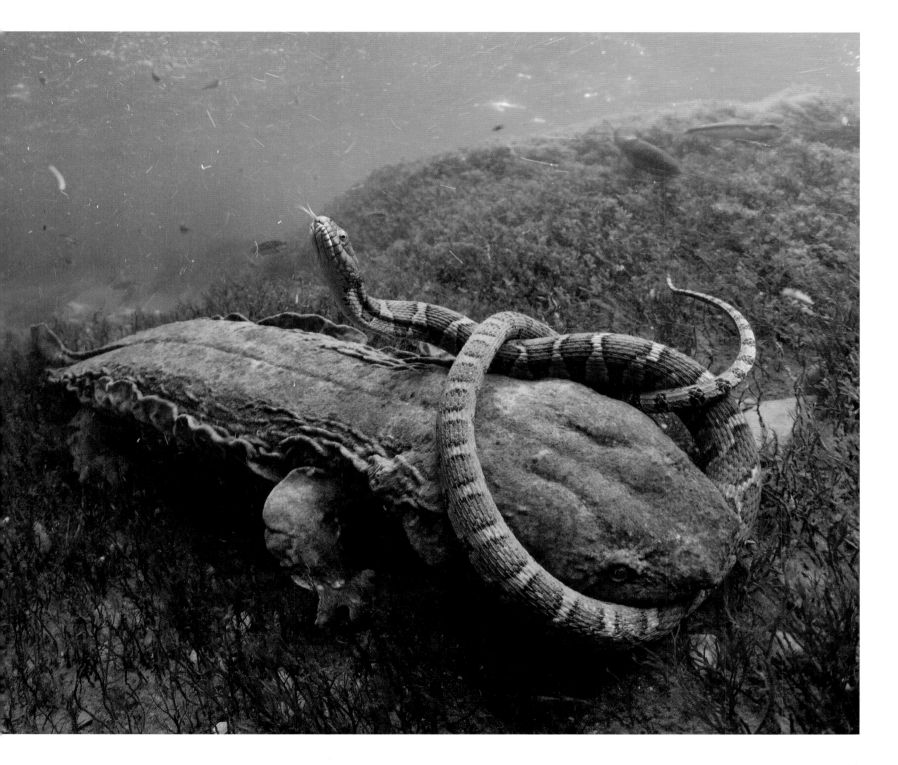

The spring ball

David Herasimtschuk

USA

Every spring, with rising temperatures and heavy rains, David heads for the same pond near Oregon's Willamette River, USA – along with hundreds of roughskin newts, migrating from forests to breed. As the females enter the water, they are often mobbed by males, resulting in writhing spawning balls. 'The males are so desperate to mate', says David, 'that I usually have a few hanging off the camera and me.' Such aggregations indicate a healthy watershed, but scientists are concerned to prevent a new fungal disease (Bsal) – fatal to the newts and other salamanders and prevalent in Europe – from getting into the system. David spent many hours floating in the icy water to seize this moment, when one male successfully embraced a female (centre, her swollen belly full of eggs), while rivals jostled beneath for a piece of the action.

Sony a7R II + 28mm f2 lens + Nauticam WWL-1 lens; 1/50 sec at f9; ISO 800; Nauticam housing; two Inon Z-240 strobes.

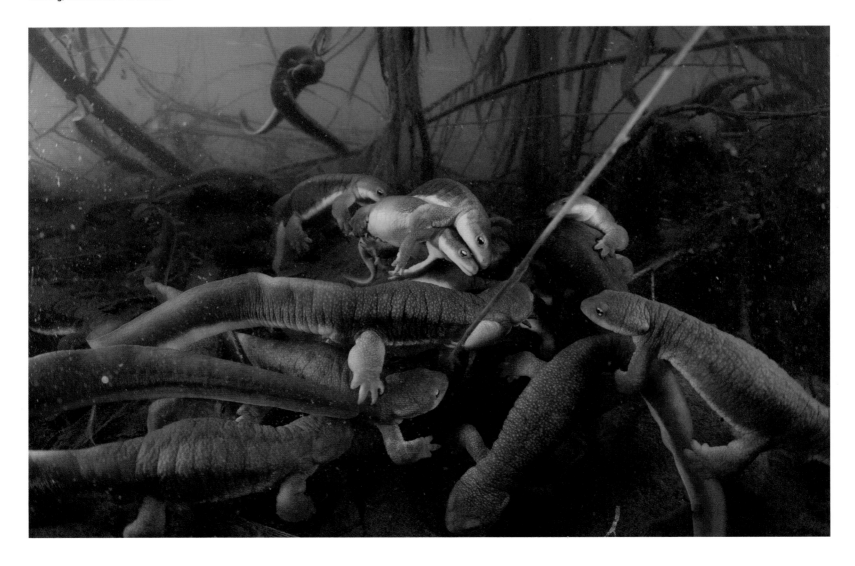

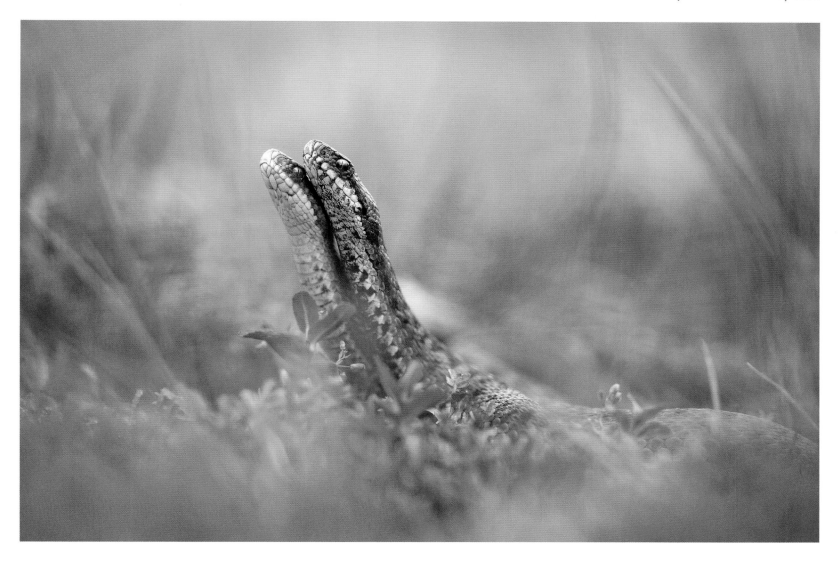

Sinuous moves

Lorenzo Shoubridge

ITALY

A thunderstorm was brewing when Lorenzo spotted the adders' heads swaying above the sphagnum moss. He was in the South Tyrol region of the Italian Alps, and the storm would be a big one. Conscious of the snakes' sensitivity to vibrations, he slid over the saturated ground on his belly, then into an icy stream flowing between him and the show. In a cheek-to-cheek dance, often seen between rival males, the courting couple performed their ritual: rising up, shifting positions, bodies entwined. If the courtship succeeded and mating resulted, the female (reddish-brown) would return to her hibernation site to give birth to live young. Lorenzo levelled on the adders' distinctive red eyes with vertical slits and isolated their swaying forms against softly blurred surroundings. Then the storm struck, the temperature plummeted, and the snakes left.

Nikon D700 + 150mm f2.8 lens; 1/320 sec at f4.5; ISO 400.

Behaviour: Invertebrates

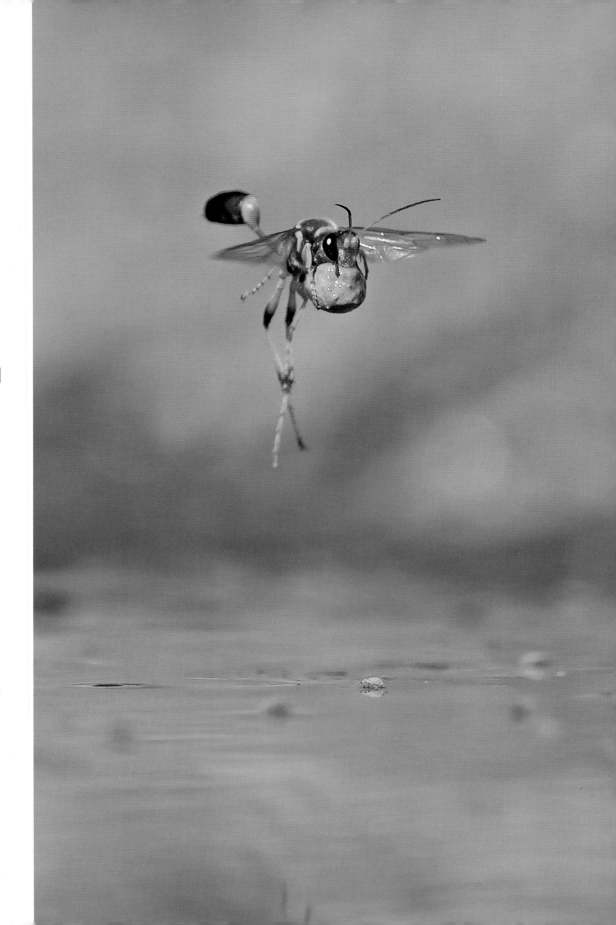

Mud-rolling mud-dauber
Georgina Steytler
AUSTRALIA

It was a hot summer day, and the waterhole at Walyormouring Nature Reserve, Western Australia, was buzzing. Georgina had got there early to photograph birds, but her attention was stolen by the industrious slender mud-dauber wasps, distinctive with their stalk-like first abdominal segments. They were females, busy digging in the soft mud at the water's edge, and then rolling the mud into balls to create egg chambers to add to their nearby nests. A female builds her external nest completely out of mud, cylindrical chamber by chamber. These cement together into one mass as the mud hardens. She provisions each of the dozen or more cocoon-like chambers with the paralyzed bodies of orb-weaving spiders, laying one egg on the first spider in each chamber. The spider is usually a soft-bodied species, easy for a newly hatched larva to eat. To get a good angle on the industrious mud-daubers, Georgina lay in the mud, pre-focused on a likely flight path and began shooting whenever a wasp entered the frame. It took hundreds of attempts to achieve her ideal shot, of two slender mud-dauber wasps, each displaying an aspect of their quintessential mud-handling skills.

Canon EOS-1D X + 600mm f4 lens + 1.4x extender; 1/4000 sec at f8; ISO 1000.

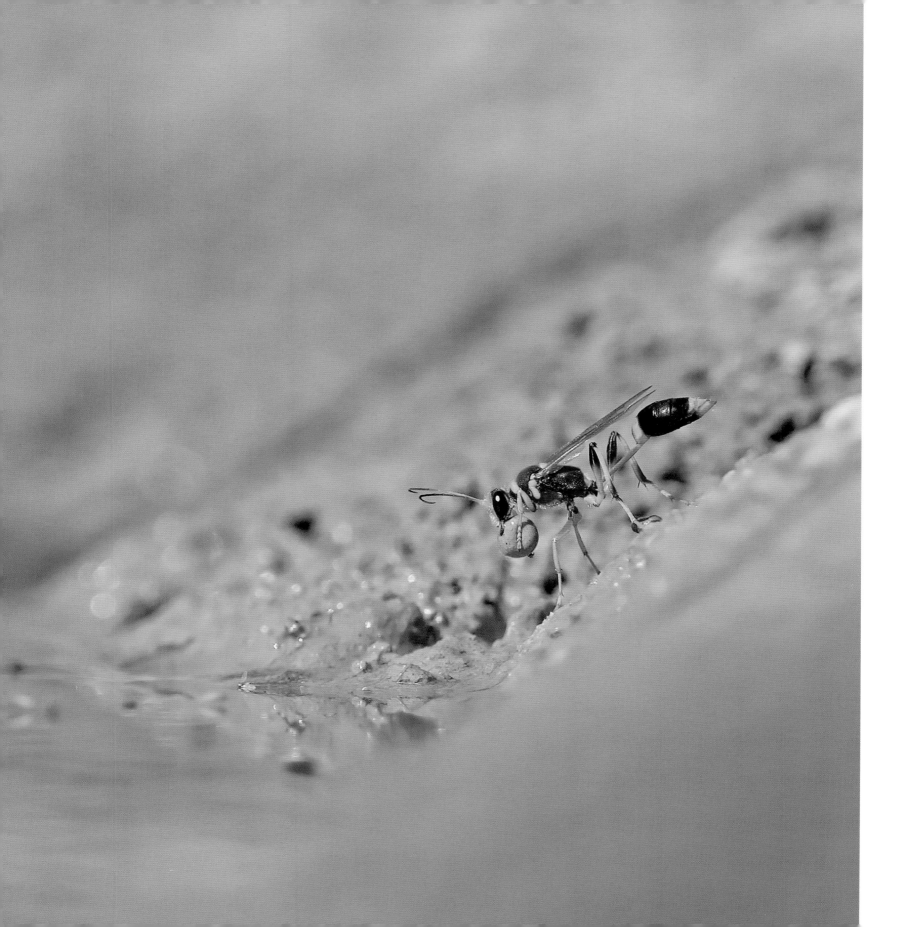

Cloak of silk

Andrés Miguel Domínguez

SPAIN

Draped like a curtain, the silken web completely covered a gorse bush in Sierra de Grazalema Natural Park, southern Spain. It was crawling with hundreds of thousands of tiny red spider mites. Only just visible to the naked eye, these plant-suckers start life with six legs, but their later nymphs and adults have eight, like their relatives, the spiders. A female may lay up to a hundred eggs, which mature rapidly into adults that in turn lay more eggs. As they move around, the mites produce silk threads for support, which together form a webbing that protects the colony against predators and bad conditions. Andrés chose a patch where the web hung in folds (dusted with yellow pollen from overhanging cork oaks and other bits of debris), and waited until sunset to take his picture, using the soft light filtering through the trees to enhance the eerie atmosphere.

Canon EOS 5D Mark III + 100mm f2.8 lens; 1/250 sec at f16; ISO 1250; tripod.

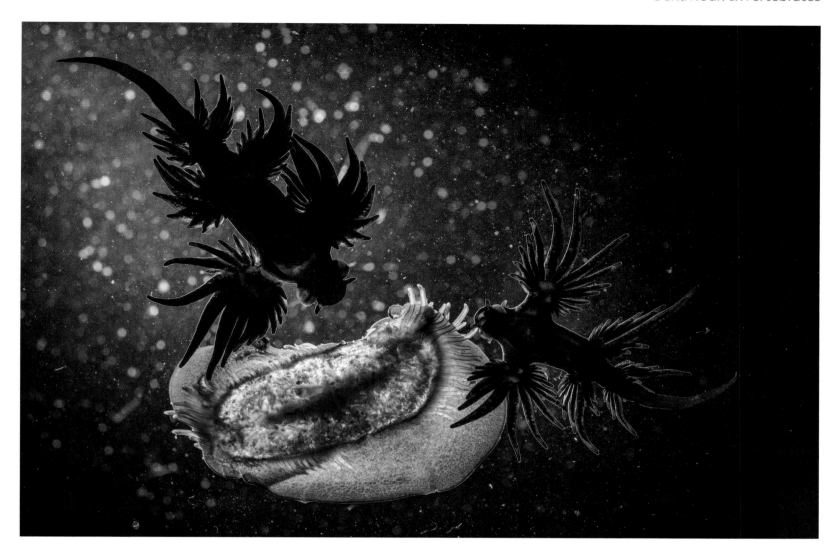

Dinner for two
Justin Gilligan
AUSTRALIA

Stranded in a rockpool on the coast of New South Wales, Australia, a pair of blue dragons feast on a by-the-wind sailor, a jellyfish-like hydrozoan. Both species normally spend their lives floating in the ocean, and when Justin spotted them, he raced to get his kit. Dragons are small nudibranchs — also known as sea slugs — that float upside down, buoyed by air bubbles in their stomachs. Camouflaged in blue from above (dark here in silhouette), they store stinging cells from prey in finger-like protrusions for use in defence. By comparison, the by-the-wind sailor (here flipped by waves) is a colony of organisms grouped into different forms, including a blue oval float, tentacles beneath and a semi-circular sail. Justin arrived back at dusk, armed with an underwater torch. Lighting his shot from beneath, he framed the elaborate forms from above against a galaxy of reflective particles.

Nikon D810 + 60mm f2.8 lens; 1/320 sec at f10; ISO 2000; Scubapro flashlight.

Trailblazer
Christian Wappl
AUSTRIA

By 1am, the forest in Thailand's Peninsular Botanic Garden was quiet, but in the leaf-litter, its nightlife still shone. The star of the show was a large firefly larva, about 8 centimetres (more than 3 inches) long, which emitted a continuous glow from four light organs at its rear. Fireflies spend most of their lives as larvae, feeding mainly on slugs and snails. This one can even tackle invasive African land snails many times its own size. Its glow – the result of a chemical reaction in its light organs – is most likely a warning to predators that it is unpalatable (whereas, the flashing lights of adult fireflies are for courtship). Framing his composition in almost complete darkness, guessing the direction the larva would take, Christian used a long (33-second) exposure, with a burst of flash at the end, to reveal the larva apparently blazing a trail through the night.

Canon EOS 5DS + 16–35mm f4 lens at 35mm; 33 sec at f5.6; ISO 1600; Yongnuo flash; cable release; Gitzo tripod.

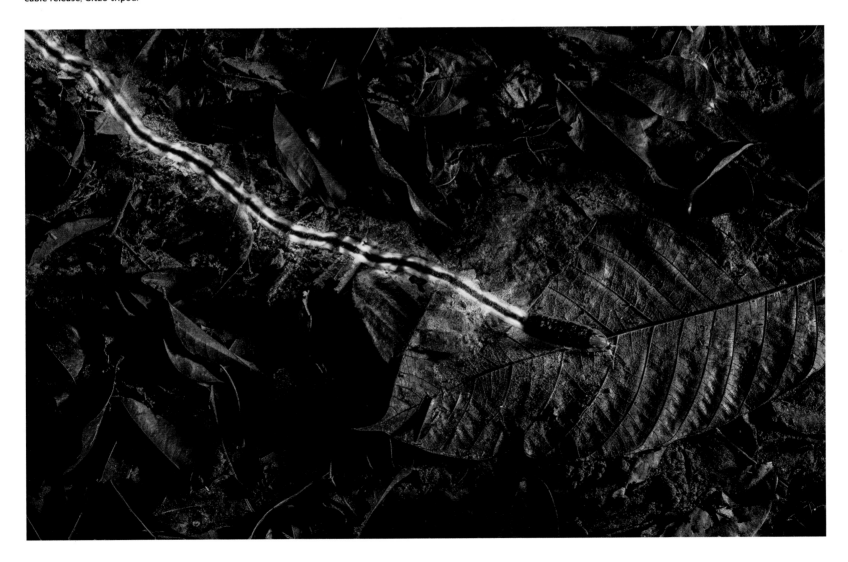

Night watch
Javier Aznar González de Rueda
SPAIN

The long, bristly legs of a harvestman extend a protective umbrella over its eggs. Javier couldn't resist stopping to look, even though it was 4am and he was exhausted from long hours in the Ecuadorian forest. Spider-like harvestmen are a widespread group – there are more than 6,500 species worldwide. All have eight legs but only two eyes (most spiders have eight), which face sideways, are often located on a turret-like structure and detect mainly light intensity. Some species invest in parental care, which includes guarding their eggs and young against predators. Javier spotted this individual poised on a leaf, a hitch-hiking red mite clinging to one of its legs. Using a small aperture and flash to maximize the depth of field (amount in focus) and diffusers to soften the light, he framed the attentive parent watching over its precious clutch.

**Canon EOS 70D + 100mm f2.8 lens + 1.4x extender; 1/250 sec at f14; ISO 100;
two Yongnuo flashes; Manfrotto tripod + Uniqball head.**

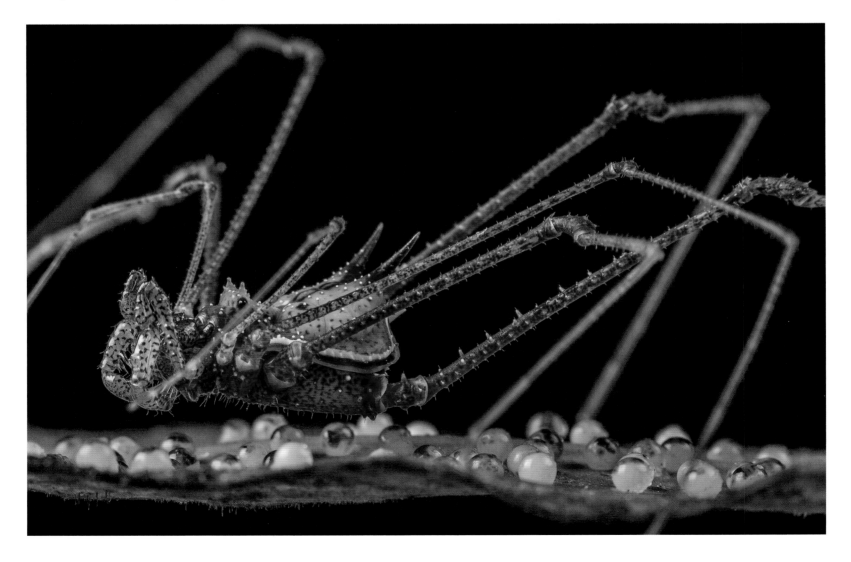

Animals in Their Environment

Bed of seals
Cristobal Serrano

SPAIN

A small ice floe in the Errera Channel at the tip of the Antarctic Peninsula provides barely enough room for a group of crabeater seals to rest, and the cracks are starting to show. It's the end of summer in the Antarctic, and so sea ice here is in short supply. Crabeater seals are widespread in Antarctica and possibly the most abundant of all seals anywhere. But they are also dependent on sea ice, for resting, breeding, avoiding predators such as killer whales and leopard seals, and accessing feeding areas. Despite their name, crabeaters are adapted to feed almost exclusively on Antarctic krill, using its interlocking, finely lobed teeth to sieve krill from the water. The krill itself is also dependent on sea ice, which provides winter shelter and food (algae). So any decline in sea ice will have a knock-on effect on such specialist krill predators, as will overfishing of krill. For the moment, there is no evidence of any decline in crabeaters, though in the vastness of their pack-ice habitat, it is very difficult to estimate their numbers. Positioned in a rubber dinghy in the channel beside the floe, Cristobal waited until the sea was relatively calm before launching his drone. The batteries would not last long in the cold, so he flew the drone 'high and smoothly ... using low-noise propellers to avoid disturbing the seals'. The picture portrays the group, dozing, with a spattering of krill-coloured seal excrement symbolizing their dependence on Antarctica's keystone species.

DJI Phantom 4 Pro Plus + 8.8–24mm f2.8–11 lens; 1/200 sec at f5.6; ISO 100.

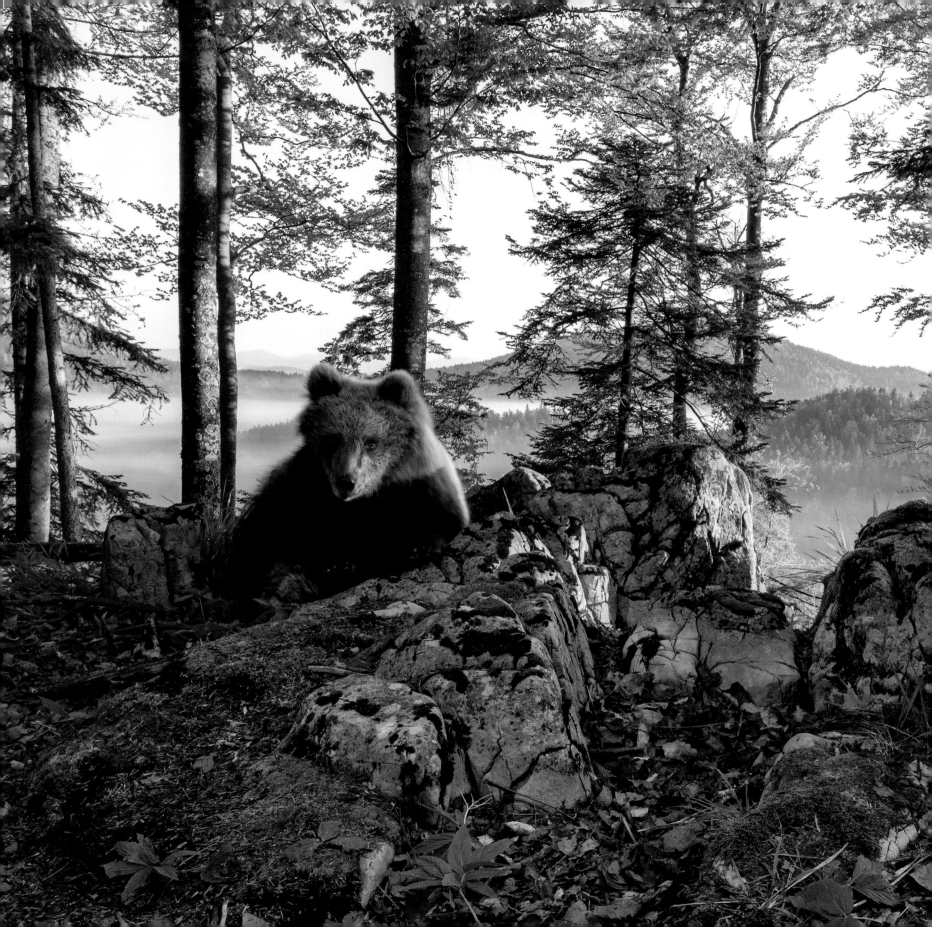

Bear territory

Marc Graf

AUSTRIA

A young brown bear climbs over the crest of a ridge as it crosses between valleys in the Dinaric Alps within Slovenia's Notranjska Regional Park. It was a sight that Marc had long awaited. Using small trail cameras, he had discovered a route that bears often used and set up his camera trap on a beech tree alongside it. But the observant bears, which are hunted in Slovenia, must have noticed that something had changed, and weeks went by without any decent results. Indeed, it took 14 months before he got this picture. The range of brown bears in Europe has contracted, and many local populations are small and fragmented. Slovenia's brown bear population is about 550, and in its mountain forest heartland, it is possibly the densest in Europe. But towards the border with Italy to the west and Austria to the north, there are very few bears, despite enough suitable habitat. Conflict with humans, including traffic accidents, is the biggest threat to these large carnivores. Keen to show brown bears as a natural element of central European mixed forests, Marc selected a wide angle to place any passing bears firmly in their environment. When he finally succeeded, it was with a young animal, lit by the early morning sun and with mist lingering over a backdrop of its forest home.

Canon 7D + 11–22mm f3.5–4.5 lens; 1/25 sec at f10; ISO 250; two Nikon SB-28 flashes; Camtraptions PIR motion sensor.

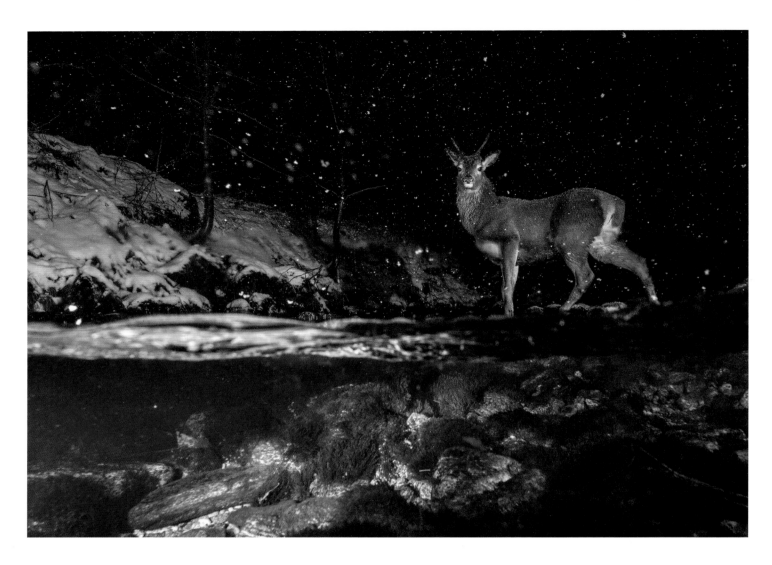

Midnight crossing

Vegard Lødøen

NORWAY

Vegard had dreamed of this picture for years. He lives in the long mountain valley of Valldal in northwestern Norway, where there are plenty of red deer. But they are hunted and wary. Vegard located many of the trails they use between night-time refuges and daily feeding grounds, but this river-crossing was the most promising location. He partly submerged his camera – disguising the housing – and set up his motion sensor and two flashes, one below the water. 'I often had to remove ice from the housing and replace batteries that failed in the cold,' he says, and the deer seemed to sense the box. But on this occasion when he went to check the camera, he saw tracks in the snow in the right place and knew he might have his shot. He did. A young male that had crossed at midnight and posed, casting a shadow on the bank behind. A sprinkling of snow added the finishing touch.

Nikon D500 + 14–24mm f2.8 lens at 14mm; 1/200 sec at f10; ISO 400; two SB-600 flashes; motion sensor + Hähnel flash trigger; home-made housing.

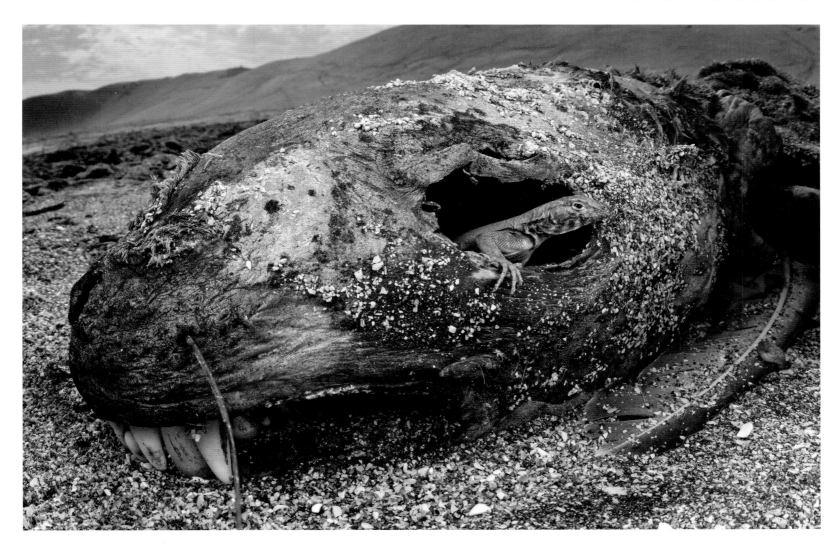

Eye to eye
Emanuele Biggi

ITALY

The stench was unbearable as Emanuele searched the carcasses for life. Fed by the sea, the desert coast of Peru's Paracas National Reserve teems with life. A colony of South American sea lions supplies the corpses – the result of illness, injuries (some from conflict with fisheries) or occasional die-offs triggered by El Niño events (when warming of the sea reduces prey availability). The decaying flesh sustains insects and crustaceans, in turn drawing larger predators. Many of the carcasses Emanuele looked at were flat or too close to the sea, but eventually he found his frame. A young male Peru Pacific iguana (distinctive black chevrons on its throat) had joined the feast within, sheltered from the harsh sun and wind. Lying on the beach, choked by the vile smell until the iguana peeped through the eye socket, Emanuele encapsulated the dependence of terrestrial life on the ocean.

Nikon D810 + Tokina 10–17mm f3.5–4.5 lens at 15mm; 1/125 sec at f18; ISO 100; SB-R200 flashes + Fotopro DMM-903 bracket.

Tigerland

Emmanuel Rondeau

FRANCE

In a remote forest, high in the Himalayas of central Bhutan, a Bengal tiger fixes his gaze on the camera. The path he treads is part of a network linking the country's national parks – corridors that are key to the conservation of this endangered subspecies but unprotected from logging and poaching. Emmanuel and a team of rangers climbed rugged terrain, with enough kit to set up eight still and eight video cameras along one route, in the hope of glimpsing a tiger pass by (there were just 103 in Bhutan at the last count). Concentrating on areas with previous tiger records, they searched for evidence of recent use – tracks, scratches and faeces – and then Emmanuel installed cameras on wooden posts in the most likely spots, composing the view so the subject would be framed within its mountain environment. After 23 days (and hundreds of false triggers by leaves and high winds), he hit the jackpot: a magnificent male tiger, and from his distinctive stripe pattern, one previously unrecorded in Bhutan. The tiger inspected the kit closely before disappearing into the forest, leaving this rare image, as if looking to us to protect his realm.

Canon EOS 550D + Sigma 10–20mm f4–5.6 lens at 16mm; 1/20 sec at f9; ISO 200; two Nikon SB-28 flashes; TrailMaster camera trigger + Camtraptions wireless flash triggers.

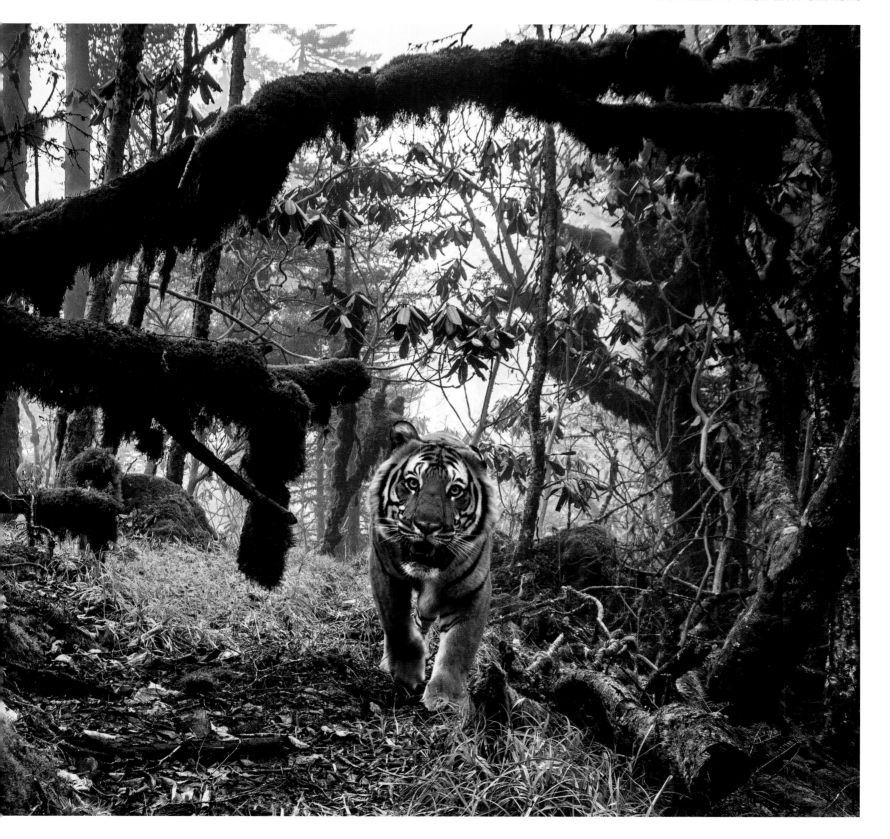

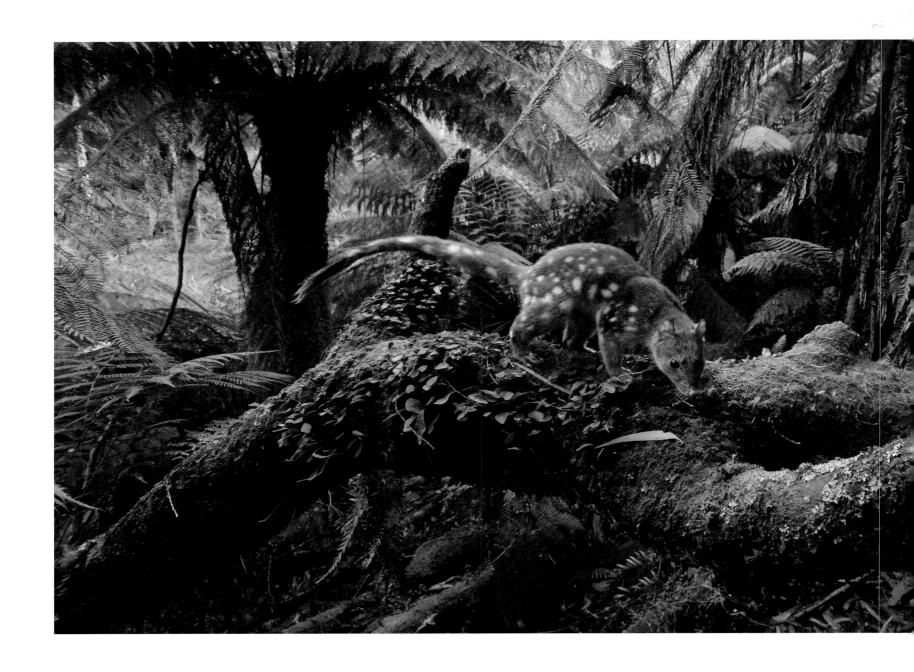

Home of the quoll
David Gallan

AUSTRALIA

The largest marsupial carnivores on mainland Australia are rare and seldom seen. It took David three years to locate spotted-tailed quolls in the forests of southeastern New South Wales and another six months to get this picture in the region's Monga National Park. Almost a metre (just over 3 feet) from nose to tail, the spotted-tailed quoll is a ferocious predator, with strong jaws and teeth and the ability to kill prey larger than itself with a bite to the back of the head. Found only in Australia, it depends on old-growth forests, which (aside from fragmented protected areas) are threatened by intensive industrial logging, primarily for woodchip export. Though the quoll is regarded as largely nocturnal, David's video recordings revealed frequent daytime activity. He set up a camera trap in front of a wall of tree ferns, where a fallen log bridged a small stream. Forgoing flash despite the gloom (to minimize disturbance and retain even lighting), he placed a scent bait station behind the log to pause any passing quolls. His perseverance paid off when this hunting female, crossing the bridge, paused on the mossy carpet and inadvertently had her portrait taken.

Nikon D7000 + Nikon 10–24mm f3.5–4.5 lens at 15mm; 1/100 sec at f4.5 (-0.67 e/v); ISO 3200; Sabre trigger; home-made housing; Manfrotto tripod.

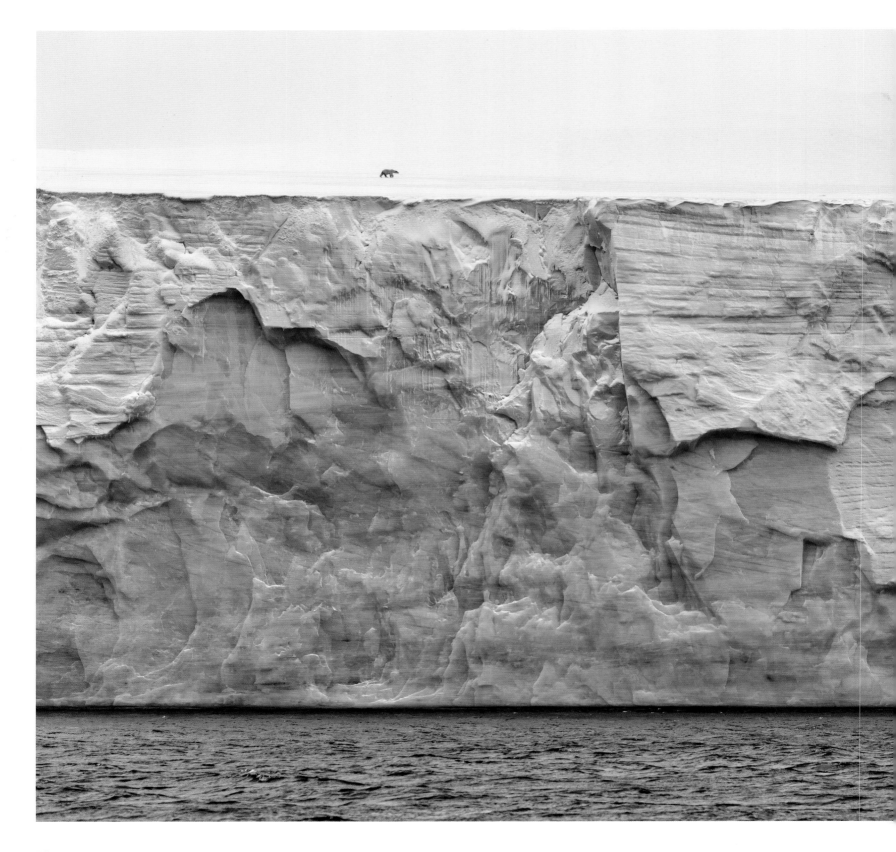

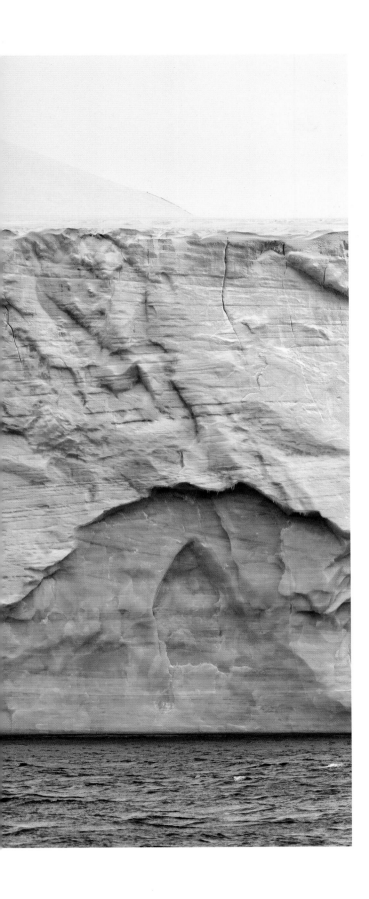

A bear on the edge
Sergey Gorshkov

RUSSIA

A polar bear cuts a lonely figure as it walks near the edge of the Champ Island glacier in Franz Josef Land, high in the Russian Arctic. This is the world's northernmost archipelago – a chain of 192 islands just 900 kilometres (560 miles) from the North Pole and a wilderness area where polar bears reign. The bear is surefooted on the glacial ice (which originates from snow on land). Its non-retractable claws dig in like ice-picks, while bumps and indents on the soles of its feet act like suction cups to secure every step. The decline in sea ice (frozen salt water), a result of climate change, makes its future uncertain. Polar bears rely on sea ice to access ringed seals, their primary prey, as well as to travel, to breed and sometimes to den. The Russian Arctic National Park has recently been expanded to include Franz Josef Land, but scientists face a lack of data for this remote region, where both numbers of polar bears and rates of sea-ice decline are unclear. The power of Sergey's composition gives no hint of the biting wind and spray he endured, but it speaks of the fragility of an icon that depends entirely on this frozen wilderness.

Nikon D5 + 70–200mm f2.8 lens at 98mm; 1/3200 sec at f5; ISO 500.

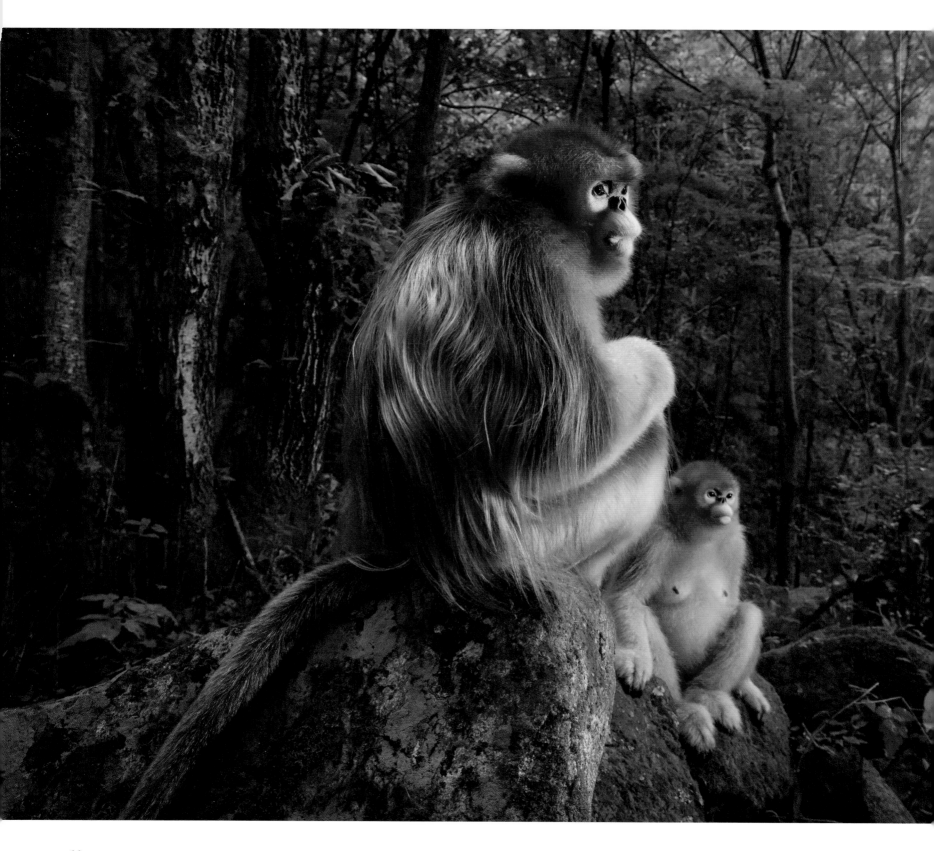

Animal Portraits

The golden couple
Marsel van Oosten

THE NETHERLANDS

Marsel considers the Qinling golden snub-nosed monkey to be the most beautiful of all the primates and has made four trips to China specifically to photograph them. This male was the leader of a group of six and has been joined by one of the females – half his size – to monitor a squabble involving two other groups further down the valley. Males are highly protective of their little groups, especially the young. Their huge canines are for show but can also be used in defence (predators can include leopards and eagles). A male's facial colour – mirrored by his genitalia – is also for show, as are his golden locks. But as males tend to sleep on their own rather than huddle with the females and young, their thick hair also provides night-time warmth, especially in the cold, snowy winters. This subspecies of golden snub-nosed monkey, confined to the Qinling Mountains, numbers no more than about 3,800 and, like the two other subspecies, is endangered. In the past hunting was a problem, and though the monkeys are now protected by law, they are still affected by forest disturbance. There is also the threat of increased visitor pressure, with a new railway station being built in the region that will give access from the cities.

Nikon D810 + Tamron 24–70mm f2.8 lens at 24mm; 1/320 sec at f8; ISO 1600; SB-910 flash.

Argentine quickstep
Darío Podestá

ARGENTINA

The day was almost a washout. When it started to rain, the dust road on the Valdes Peninsula in Patagonia, Argentina, filled with mud, and Darío started to head home. He stopped to grab a few shots of a salt lake under the dramatic sky, when to his delight, a family of two-banded plovers appeared. These small, shy migratory birds breed along the shore and wetlands at the southern tip of South America. Within a few hours of hatching, the chicks leave the nest (a shallow scrape among vegetation, easily crushed by vehicles), relying on their incongruous legs to keep up with their parents and to evade predators. It was an uncomfortable crawl in the rain, across mud and salt, to get near to the constantly moving birds, but Darío managed to capture a portrait that shows the fragility of the chick as it scurries after its parents, its speckled fluff and dark legs bold against the pale backdrop of salt.

Canon EOS-1D X + 300mm f2.8 lens + 2x extender; 1/1600 sec at f5.6 (+1.3 e/v); ISO 1000.

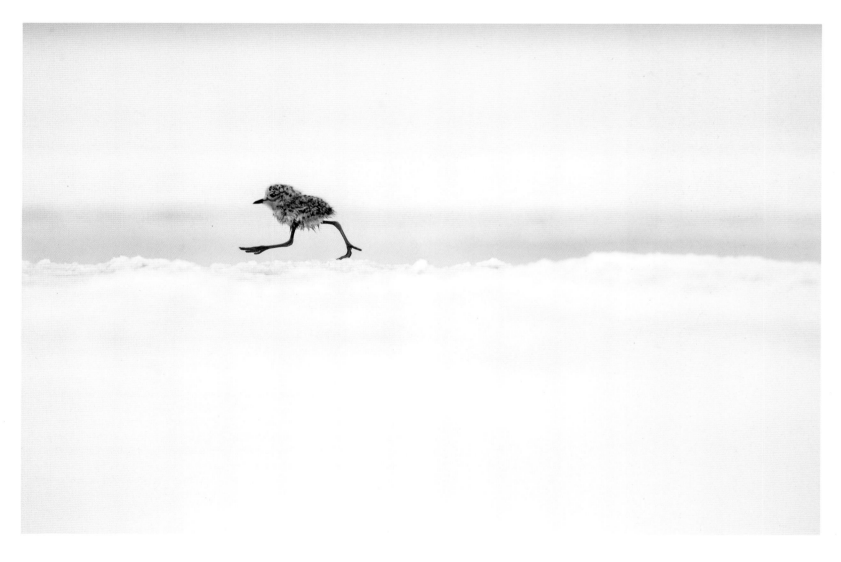

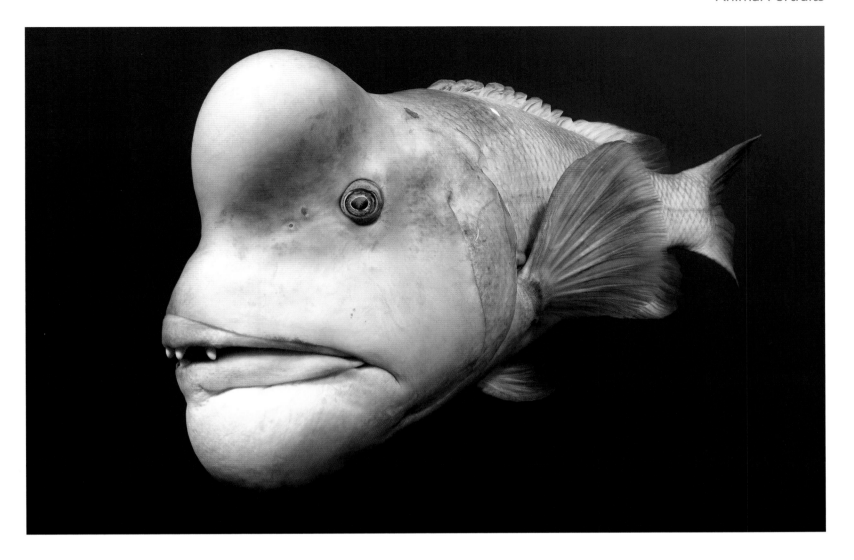

Looking for love
Tony Wu
USA

Accentuating his mature appearance with pastel colours, protruding lips and an outstanding pink forehead, this Asian sheepshead wrasse sets out to impress females and see off rivals, which he will head-butt and bite. Tony has long been fascinated by the species' looks and life history. Individuals start out as females, and when they reach a certain age and size – up to a metre (more than 3 feet) long – can transform into males. Long-lived and slow-growing, the species is intrinsically vulnerable to overfishing. It favours rocky reefs in cool waters in the Western Pacific, where it feeds on shellfish and crustaceans, though little more is known about it. In a window of calm, amid high seas, Tony reached Japan's remote Sado Island, to reveal some of the drama of the wrasses' lives. Here, he conveys the suitor's earnest intentions, written large on his face.

Nikon D800 + Sigma 15mm f2.8 lens; 1/200 sec at f11; ISO 200; Nauticam housing; Pro-One dome port; two Nikon SB-910 flashes + custom Zillion housings.

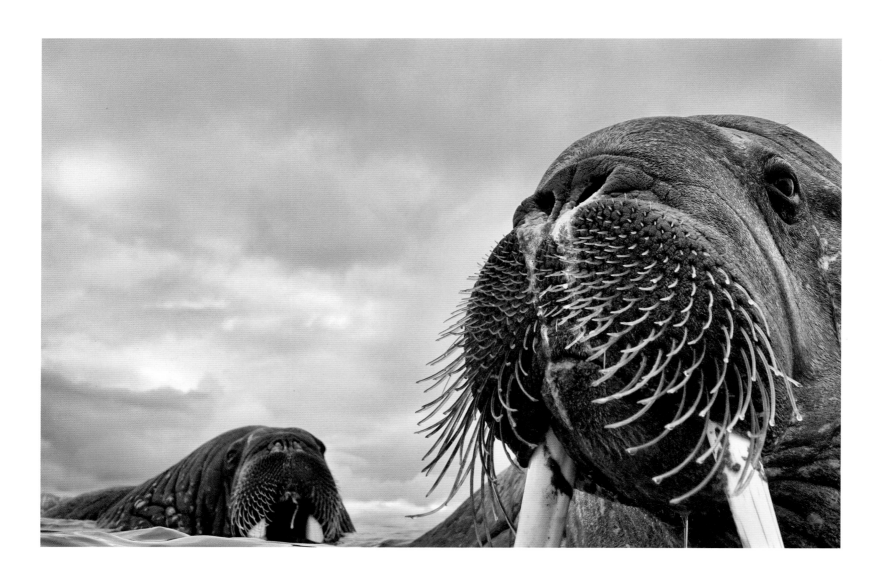

Mister Whiskers
Valter Bernardeschi

ITALY

It was a bright summer's night when Valter came across the walruses. They were feeding just off an island in the Norwegian archipelago off Svalbard. Putting on his wetsuit, and using a couple of monopod poles and a float to extend his camera in front of him, Valter slipped into the icy water. Immediately, a few curious walruses – mainly youngsters – began swimming towards him. Clumsy on land, these weighty giants now moved with ease and speed. Keeping at pole's length, he was able to take this intimate portrait of the distinctive whiskered faces of a youngster and its watchful mother. Walruses use their highly sensitive whiskers and snout to search out bivalve molluscs (such as clams) and other small invertebrates on the ocean floor. In the cold water, their thick protective skin appears grey when blood flow to its surface is reduced, but darker, reddish-brown when they are out of water and have warmed up. The tusks are not used for feeding but for display among the males, for defence against polar bears and for hauling themselves out, especially onto sea ice. They will rest on ice floes between bouts of feeding and even give birth on them.

Sony ILCE-7RM2 + 28mm f2.8 lens + ultrawide converter; 1/800 sec at f8; ISO 1250; Nimar II housing; Nikonos remote control; Feisol monopod.

Cool cat

Isak Pretorius

SOUTH AFRICA

A lioness drinks from a waterhole in Zambia's South Luangwa National Park. She is one of the Mfuwe Lodge pride – two males, five females and five cubs. Isak had been keeping watch on them while they slept off a feast from a buffalo kill the night before. Lions kill more than 95 per cent of their prey at night and may spend 18–20 hours resting. When this female got up and walked off, Isak anticipated that she might be going for a drink, and so he headed for the nearest waterhole. Though lions can get most of the moisture they need from their prey and even from plants, they drink regularly when water is available. Isak positioned his vehicle on the opposite side of the waterhole, close to the edge, steadying his long lens in the low light on a bean bag. Sure enough, the lioness appeared through the tall, rainy-season grass and hunched down to drink, occasionally looking up or sideways. With perfect timing, Isak caught her gaze and her tongue, lapping the water, framed by the wall of lush green.

Canon EOS-1D X Mark II + 600mm f4 lens; 1/400 sec at f4; ISO 1600.

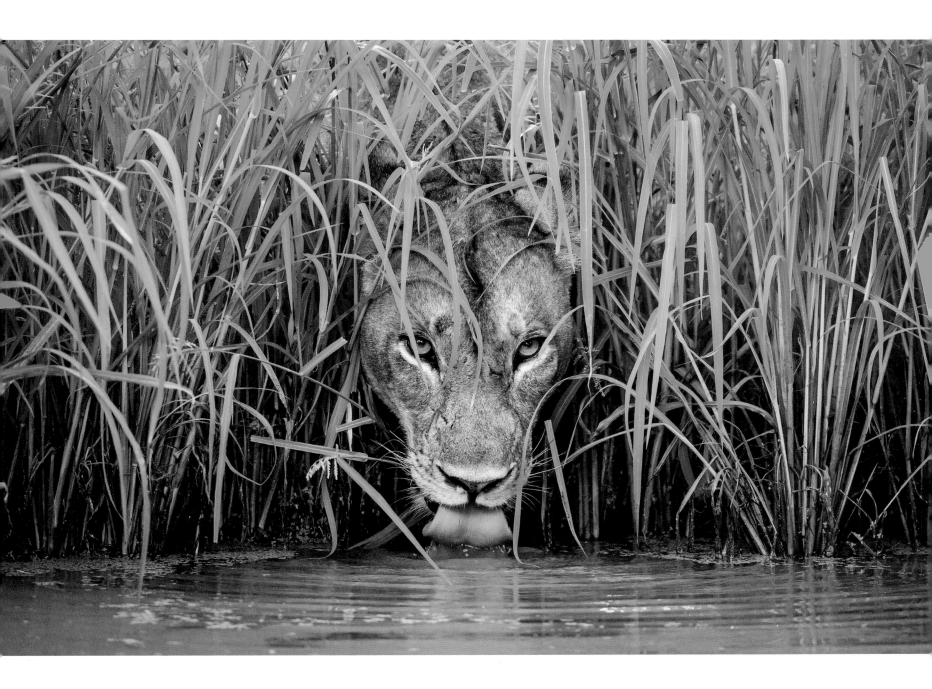

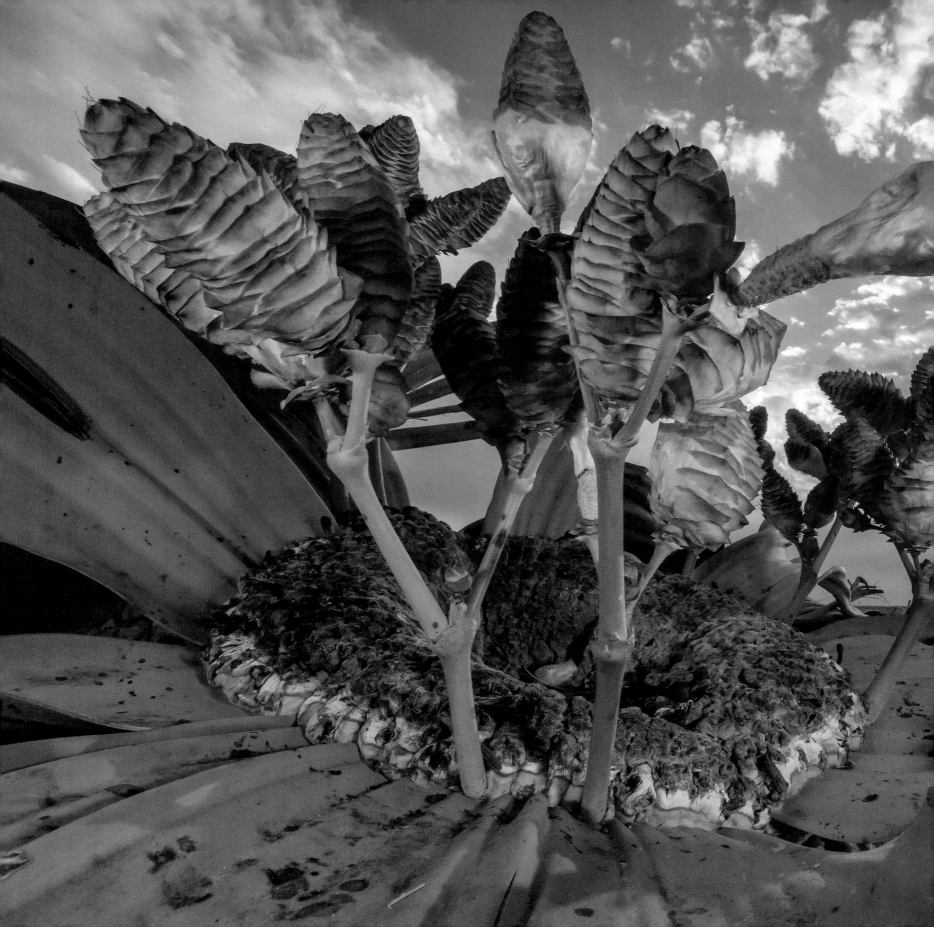

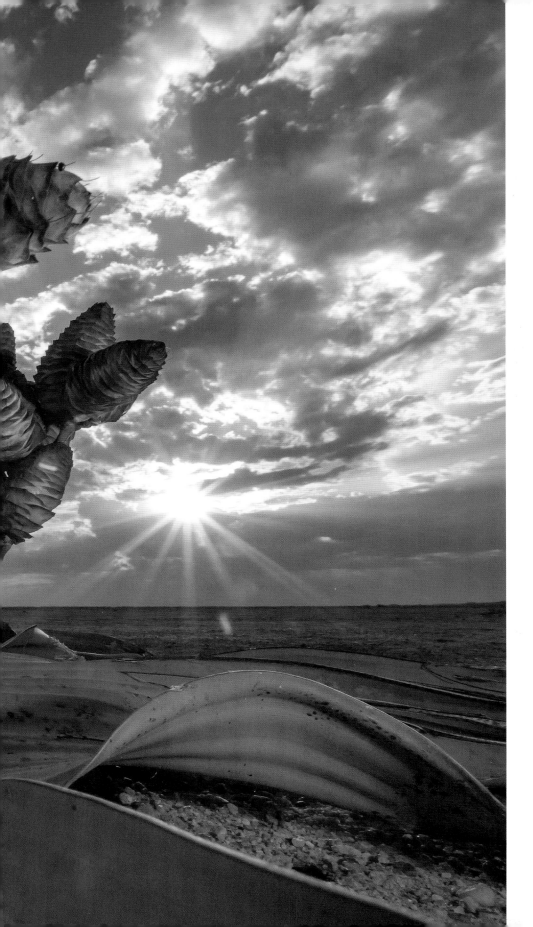

Plants and Fungi

Desert relic
Jen Guyton
GERMANY/USA

The cones of a female welwitschia reach for the skies over the Namib Desert, proffering sweet nectar to insect pollinators. These desert survivors have an extraordinary biology. There are male and female plants, both producing distinctive cones. Each plant comprises just two leaves, a stem base and a tap root. The woody stem stops growing at the apex but widens with age, forming a concave disc, but the two original seedling leaves continue to grow, gradually splitting and fraying. With a slow growth rate and the largest specimens spanning more than 8 metres (26 feet), some may be 1,000 years old or more (twice that has been claimed). Endemic to Namibia and Angola, welwitschia endures harsh, arid conditions, usually within 150 kilometres (90 miles) of the coast, where its leaves capture moisture from sea fog. Jen's challenge was to find a striking way to photograph what can be seen as just a pile of old leaves. After trekking all day over hot sand, scouting widely scattered plants, Jen found one about 1.5 metres (5 feet) across, and with 'the right shape and lively colours'. It had ripening cones, some with their papery wings ready to detach and carry the seeds away on the wind. Adopting a low, wide angle to catch the vibrant tones and to display the plant's architecture against the expansive landscape, she started shooting just as the sun was going down and while a scattering of clouds rolled in and diffused the light.

Canon EOS 7D + Sigma 10–20mm f4–5.6 lens at 10mm; 1/100 sec at f22; ISO 400; Venus Laowa flash; Manfrotto tripod.

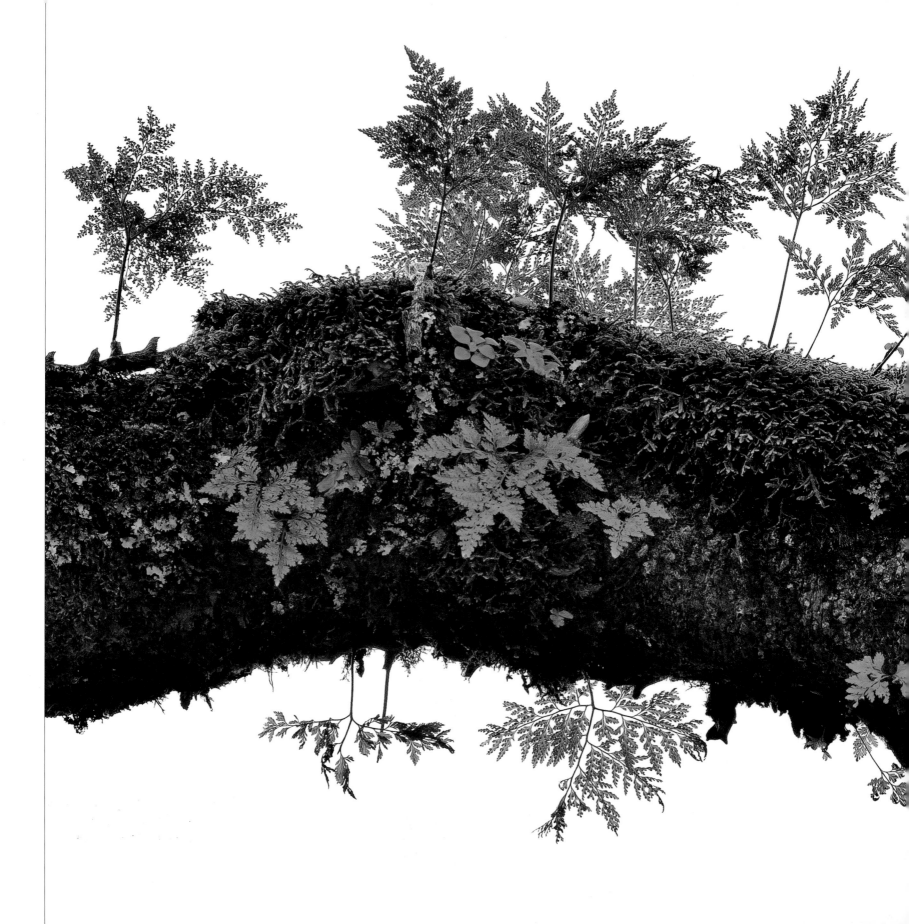

Forest on a tree
Antonio Fernandez
SPAIN

The arms of immense trees stretched eerily into the mist permeating Madeira's Fanal Forest. Among them was this low tilo branch with ferns growing all along it, 'like a forest within a forest', says Antonio. The mighty tilo tree – an evergreen laurel which can reach more than 40 metres (130 feet) tall – is found only in Madeira and the Canary Islands. It is a dominant element of the island's laurisilva – the largest relic of the laurel forest that once extended across southern Europe and northwestern Africa. Now threatened mainly by invasive species, this humid expanse is home to a wealth of plants and animals, many of them found nowhere else. Key to Antonio's miniature forest was the hare's foot fern, with broad, finely divided fronds. It occurs in the western Mediterranean, Canary Islands and Madeira. Like other epiphytes (plants that grow on other plants), it garners water and nutrients from the air, rain or plant debris and relies on the host plant for support. As the breeze threaded through the trees, it stirred up the ubiquitous fog, frustrating Antonio's desire for a uniformly intense backdrop. But in a moment of calm, he realized the simple elements of his composition, isolated against pure white.

Nikon D810 + Nikon 70–200mm f2.8 lens at 185mm; 1/20 sec at f10; ISO 250; Benro tripod + Arca-Swiss head.

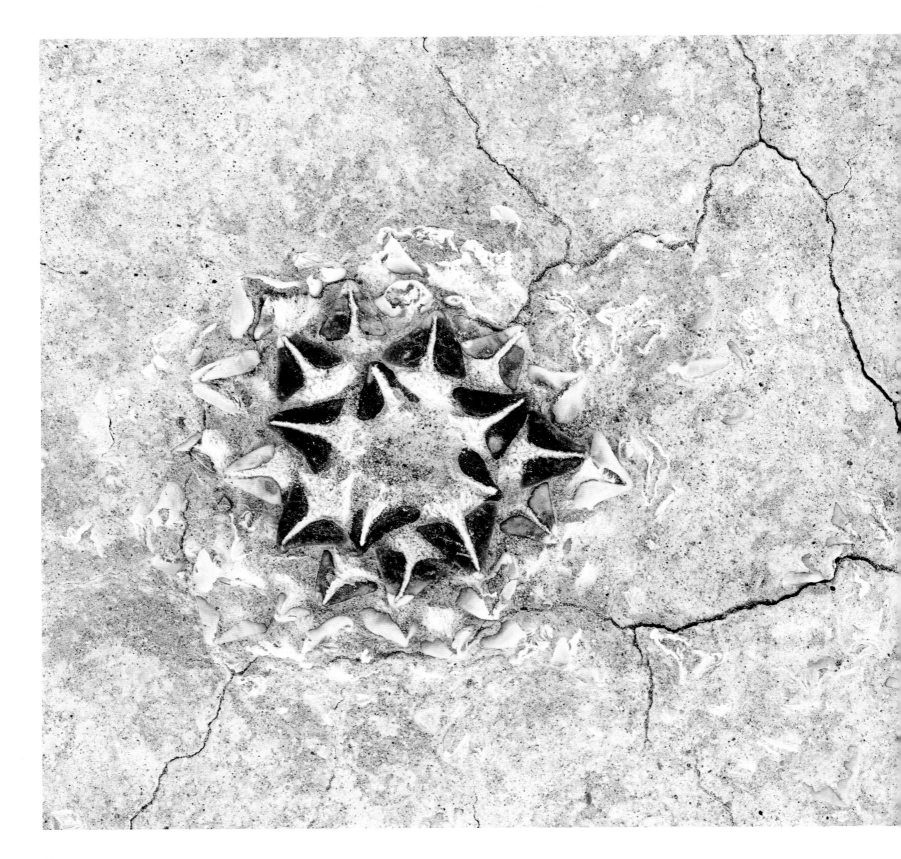

A rock in a hard place
Stefano Baglioni
ITALY

A diminutive living rock breaks the surface of the parched plains of Coahuila, northeast Mexico, emerging like a fossil from the dust. This living rock cactus is widely distributed around the edges of the vast Chihuahuan Desert (home to nearly a quarter of the world's cactus species), but as a calcareous (chalky) soil specialist, mostly confined to silty floodplains, its populations are fragmented. Many are threatened by habitat loss and degradation, as well as collection, including for medicinal use as anti-inflammatories and painkillers. In the rainy season, these succulents can withstand being submerged for days, and when the flood water recedes, they remain hard to spot. Inconspicuous except when flowering (with pale mauve blooms in this northerly form), just a few centimetres across and seldom rising above ground level, the living rock is often obscured by blown dust. As Stefano knelt to set up his camera, the ground was still scorching – earlier temperatures had topped 40˚C (104˚F). He caught the moment just before sunset, when soft light enhanced the form and colours, the cracked concrete earth testifying to the unstoppable life force of the little plant.

Nikon D800 + 105mm f2.8 lens; 1 sec at f16; ISO 100; Gitzo tripod + Manfrotto head.

Golden island in a lotus sea
Zorica Kovacevic

SERBIA/USA

Botswana's Okavango Delta was encrusted with floating lotus leaves and dotted with forested islands of all shapes and sizes. 'Flying over it was like a treasure hunt,' says Zorica. She struck gold when she spotted one perfectly round oasis, sufficiently isolated to be framed alone amid the sea of lotus leaves. Unlike most large inland deltas, the Okavango does not open into the ocean. Its vast maze of waterways drain into the sands of the Kalahari Basin – flooding in the wet season and supporting a rich biodiversity. Variation in the density of lotus plants brought light and shade to the canvas, their oval, waxy leaves rising on long stalks. From the centrepiece – an island 30 metres (100 feet) wide – rose an array of plants. The green arches of wild date palms burst like fountains, with dried petticoats of old fronds hanging below. A jackalberry tree – its new leaves conspicuously orange – added the finishing touch to the composition. Leaning out of the helicopter's open door, Zorica had just a moment to capture all this.

Nikon D4S + 24–120mm f4 lens at 78mm; 1/640 sec at f6.3; ISO 1600.

Under Water

Night flight
Michael Patrick O'Neill
USA

On a night dive over deep water – in the Atlantic, far off Florida's Palm Beach – Michael achieved a long-held goal, to photograph a flying fish so as to convey the speed, motion and beauty of this 'fantastic creature'. By day, these fish are almost impossible to approach. Living at the surface, they are potential prey for a great many animals, including tuna, marlin and mackerel. But they have the ability to sprint away from danger, rapidly beating their unevenly forked tails (the lower lobe is longer than the upper one) to build enough speed to soar up and out of the water. Spreading their long, pointed pectoral fins like wings, flying fish can glide for several hundred metres (more than 650 feet). At night, they are more approachable, moving slowly as they feed on planktonic animals close to the surface. In a calm ocean, Michael was able to get closer and closer to this individual, which became relaxed in his presence. In the pitch black, he tried various camera and light settings, all the while keeping track of both his subject – a mere 13 centimetres (5 inches) long – and his dive boat. The result is his 'innerspace' vision of a flying fish.

Nikon D4 + 60mm f2.8 lens; 1/8 sec at f16; ISO 500; Aquatica housing; two Inon Z-220 strobes.

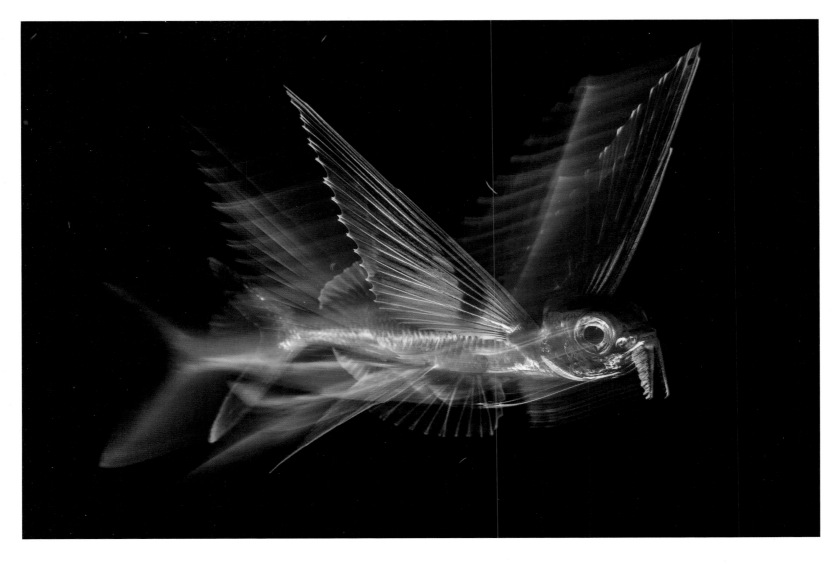

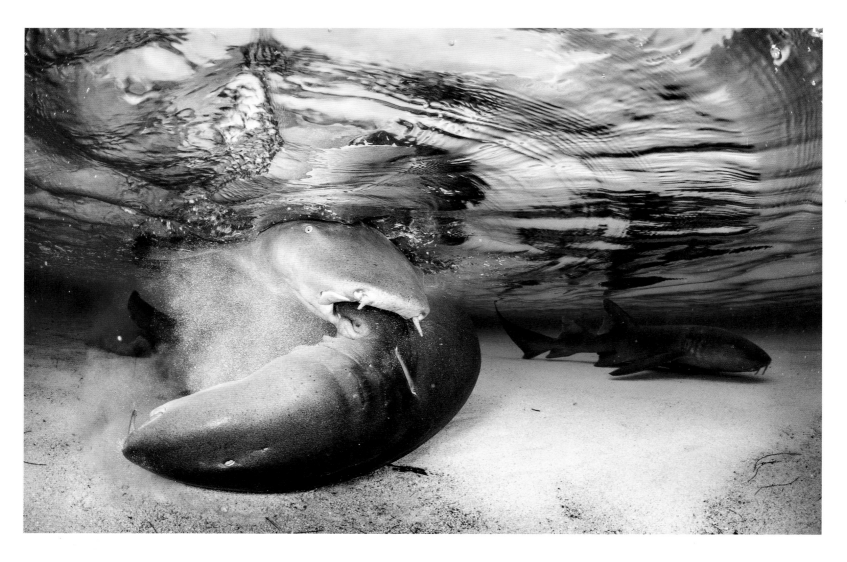

Shark sex in the shallows
Shane Gross

CANADA

Shane woke at dawn to the sound of splashing. Scrambling to look out of his tent, he saw 'a pile of 14 nurse sharks thrashing around in knee-deep water'. He knew that, in summer, when sunrise coincided with high tide, nurse sharks came to this bay on The Bahamas island of Eleuthera to mate. So the previous evening, when he had seen them heading for the shallows, he had camped out on the beach. Nurse shark mating is no gentle affair. The male bites the female's pectoral fin, rolling her over and pinning her to the seabed. Many males may attempt to mate with a single female – who tries to avoid them by swimming into shallow water and burying her pectoral fins in the sand. Shane managed to get in close to the action, catching the tiny eyes of the mating pair, while avoiding getting in the way of the other sharks.

Nikon D90 + Tokina 10–17mm f3.5–4.5 lens at 10mm; 1/50 sec at f14; ISO 400; Aquatica housing; two Sea & Sea YS250 strobes.

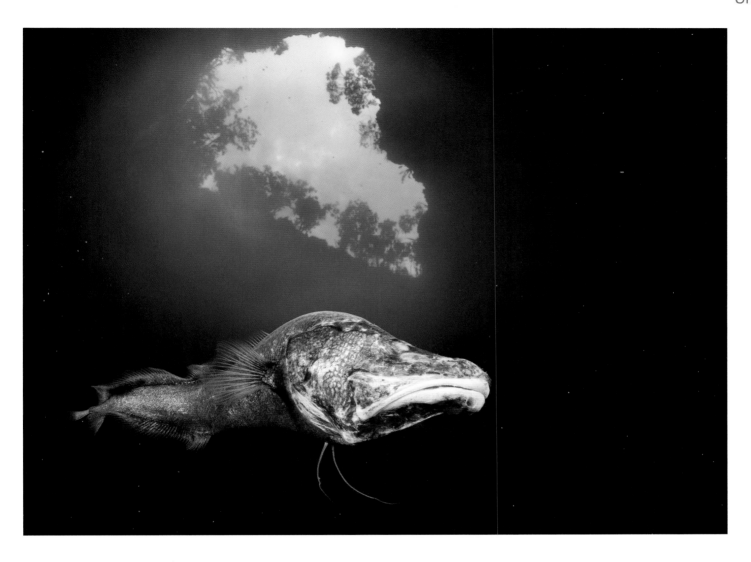

Beneath the blue
Shane Gross

CANADA

In the cold, clear depths of Eleuthera's Sapphire Blue Hole cavern floats a Bahama cavefish. About 18 centimetres (7 inches) long and almost blind, it hugs the side to avoid the light and slowly snakes along. Shane had looked for it many times – a species found only in The Bahamas, in a dozen or so inland sinkholes that have been carved by water from limestone and connect below ground to the sea. The fish moves between surface fresh water and salt water deeper down, feeding on invertebrates such as shrimps, and is very sensitive to changes in water quality. This pool was tricky to reach, being encircled by a 6-metre (20-foot) cliff. 'I lowered my camera and diving gear by rope,' says Shane. 'Then, I jumped.' At last, he found a fish that was not too shy. A sense of place was created by picturing it beneath the tree-framed interface, with the sunlit world above.

Nikon D500 + Tokina 10–17mm f3.5–4.5 lens at 11.5mm; 1/250 sec at f22; ISO 1000; Aquatica housing; two Sea & Sea YS250 strobes.

Glass-house guard

Wayne Jones

AUSTRALIA

On the sandy seabed off the coast of Mabini in the Philippines, a yellow pygmy goby guards its home – a discarded glass bottle. It is one of a pair, each no more than 4 centimetres (1 and a half inches) long, that have chosen a bottle as a perfect temporary home. The female will lay several batches of eggs, while the male performs guard duty at the entrance. Setting up his camera a few centimetres in front of the bottle's narrow opening, Wayne positioned his two strobes – one at the base of the bottle to illuminate the interior, and the other at the front to light the goby's characteristic surprised face. Opting for a shallow depth of field, Wayne focused on the goby's bulging blue eyes, allowing the movement of the fish to blur the rest of its features into a haze of yellow, and framing its portrait with the circular entrance to the bottle.

Canon EOS 5D Mark IV + 100mm f2.8 lens + Nauticam super macro converter (SMC-1);
1/200 sec at f8; ISO 200; Nauticam housing; two Sea & Sea strobes.

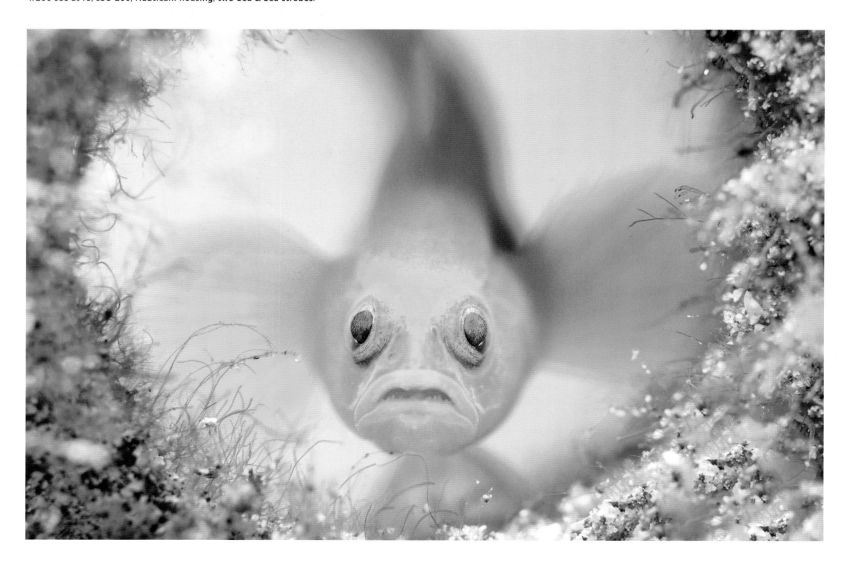

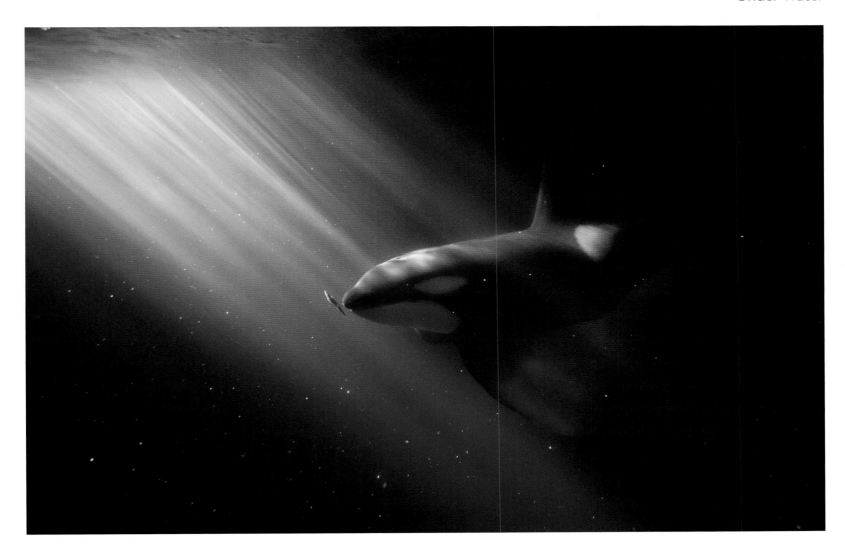

Night snack

Audun Rikardsen

NORWAY

Audun had long awaited the chance to document how killer whales continue to feed in the dark, and in Kaldfjord, outside Tromsø, in northern Norway, the elements finally came together. It was polar night, with just a few hours of dim light spilling over the horizon around midday. Large numbers of herring were overwintering in the fjords, attracting whales and fishing boats. The boats usually fished in darkness, and the killer whales knew that the sound of nets being hauled up meant the possibility of an easy meal. 'When a crew finished fishing and retrieved their net,' explains Audun, 'I could see the killer whales still feeding on herring drifting around the boat.' At his request, the fishermen angled their strongest light into the water. Despite the harsh cold and inky ocean, Audun was finally able to get his shot of a killer whale amid herring scales, hunting the last few fish in the dark, transiently lit by the boat's beam.

Canon EOS 5D Mark IV + 14mm f2.8 lens; 1/80 sec at f2.8; ISO 1600; Aquatech housing.

Urban Wildlife

Crossing paths
Marco Colombo

ITALY

A shadowy movement caught Marco's eye as he drove slowly through a village in the Abruzzo, Lazio and Molise National Park in Italy's Apennine Mountains. It was late evening, and he thought there was a chance that it might be a Marsican brown bear rather than a deer waiting to cross the road. Stopping the car, he switched off the lights to avoid stressing the animal. He had just a few minutes to change lenses and prepare to take a shot through the windscreen before the bear walked out of the shadows and across the road, disappearing into the dark of the woods. Though the light was poor, the backdrop made up for it, complete with nature-tourism posters. Most Marsican brown bears – an isolated, unaggressive and critically endangered subspecies – stay well away from humans. A few individuals, though, venture into villages to raid vegetable gardens and orchards, especially in the run-up to winter hibernation, when they need to lay down fat. This puts them at risk of being hit by cars, of retaliatory poisoning and of harassment: video clips have appeared on social media made of bears being chased by cars. With just 50 or so bears remaining, every death is a disaster. Coexistence is possible, but only if a respectful distance is maintained. Electric fences around orchards help deter the bears from coming into the villages, and education can protect both the bears and the nature tourism they attract.

Nikon D700 + 28–70mm lens at 70mm; 1/50 sec at f4; ISO 6400; MaGear harness.

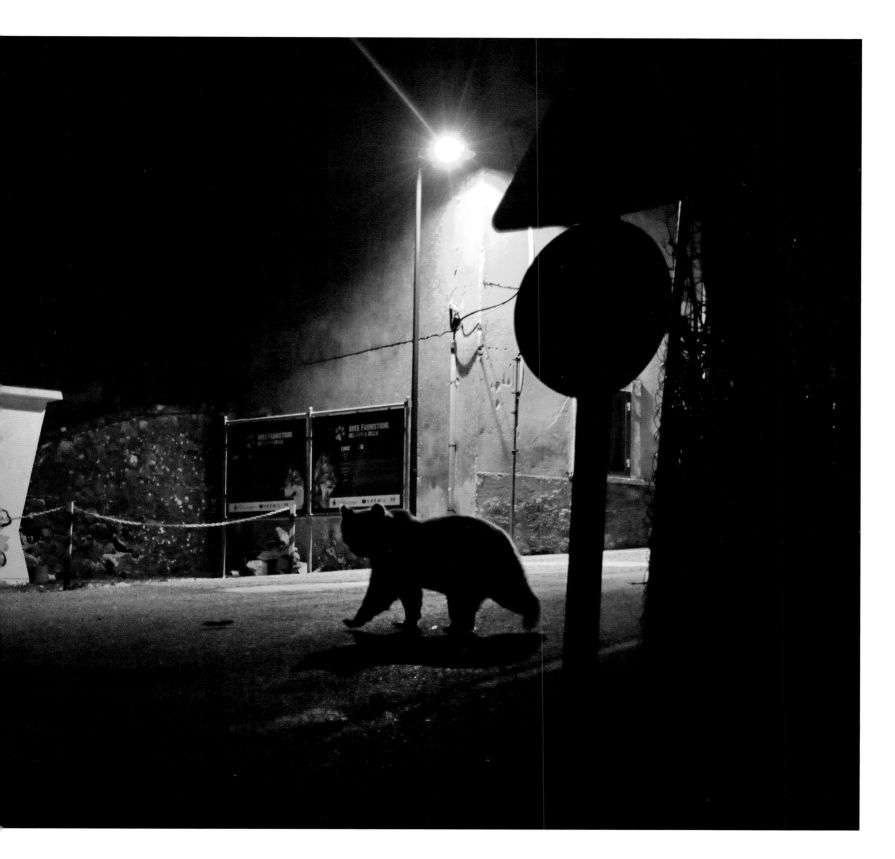

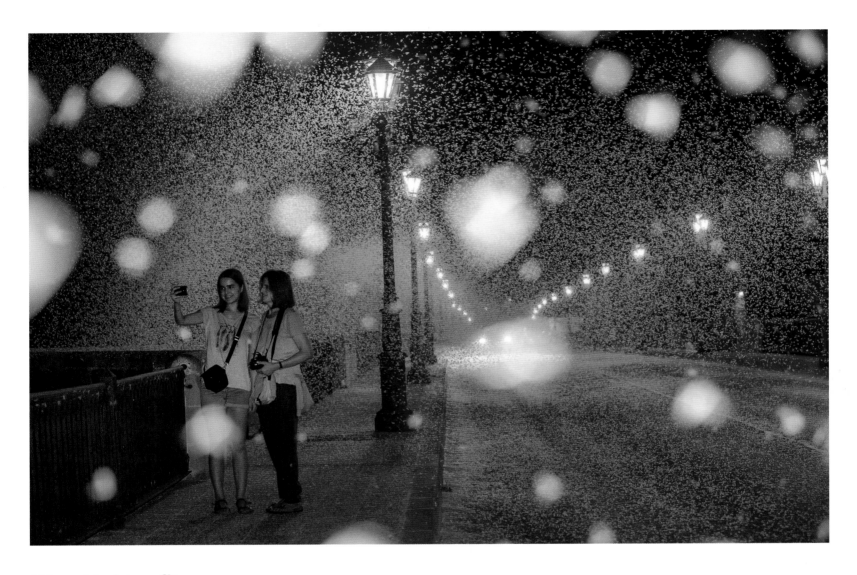

Misguided mayflies

Jose Manuel Grandio

SPAIN

A living blizzard of wings provides a spectacle for sightseers on a bridge over the River Ebro in the small Spanish city of Tudela. It's both a marvel and a tragedy. So great is the swarm, comprising millions of mayflies, that even cars slow down. It's a spectacle that occurs on one night every year between mid-August and mid-September. The mayflies emerge from the river en masse, split out of their pupal skins, rise up in the sky as winged adults, and embrace and mate. The mating swarm may last just 15 minutes. The males then die, and the females fly upriver to lay their eggs. Here, though, the lamplight reflecting off the dark road surface resembles moonlight on the river and lures the females onto the asphalt. Such a spectacle of mass futility has yet to convince the authorities to turn off the street lights and let the summer night of love give rise to a new generation.

Nikon D4 + 24–70mm f2.8 lens; 1/125 sec at f4; ISO 1600; Nikon SB-800 flash.

City fisher
Felix Heintzenberg
GERMANY/SWEDEN

The rusty metal rod at the opening of a sewage outlet pipe became a favourite perch for a kingfisher pair, offering views of shoals of small fish (mainly roach) in the water below. The presence of the fish and the kingfishers was a sign that the water was clean, having passed through the treatment plant servicing Lund in southern Sweden. In spring, Felix regularly visited this urban stretch of the River Höje near his home to get to know the fishing habits of the kingfisher territory-holders. Seeing the photographic potential of the colourful spot, he adjusted the angle of the rod so a perching kingfisher, lit with a gentle flash, could be seen against the dark opening of the outlet. Felix's main challenge then became questions from passers-by wanting to know why his lens was aimed at a sewer pipe.

Canon EOS-1D X + 100–400mm f4.5–5.6 lens at 110mm; 1/25 sec at f14; ISO 100; Speedlite 580EX II flash + two 540EZ flashes; tripod; Pocket Wizard Plus II transceiver; hide.

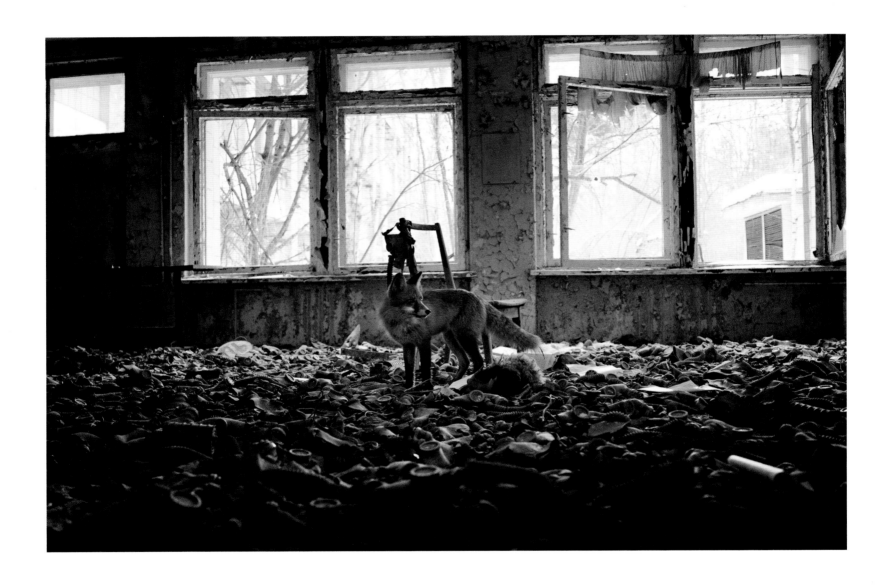

School visit

Adrian Bliss

UK

Adrian was exploring the derelict schoolroom when the red fox trotted in, perhaps curious about the human or perhaps just on its rounds. It stopped briefly on the carpet of child-sized gas masks, just long enough for a picture, and then exited through a broken window. The school in Pripyat, Ukraine, was abandoned in 1986, as was the whole city, following the catastrophic explosion at the Chernobyl nuclear power plant, just 3 kilometres (nearly 2 miles) away. It was the worst nuclear accident in history, spreading radioactive fallout across Europe. Pripyat's buildings are now decaying and have been looted (the children's gas masks – Cold War relics – were left as being of no value). The city lies within the 30-kilometre (19-mile) exclusion zone, which only accredited individuals can enter, and in the absence of humans, the forest is moving back in. Animals such as wild boar, deer, moose and lynx are making a comeback, and there are even sightings of brown bears and wolves. Though there were areas of the zone that Adrian was advised not to enter because radiation levels were still too high, and though the long-term effect of radiation on the animals is far from clear, wildlife appears to be thriving.

Sony RX1Rii + 35mm f2 lens; 1/125 sec at f3.2; ISO 2000.

Smoke bath

Tom Kennedy

IRELAND

On a cold November morning, Tom glanced out of his living-room window in southern Ireland to see a rook perched on a neighbour's chimney pot engulfed in smoke. With its wings spread, it was allowing smoke from the recently lit fire to engulf it. After a couple of minutes, apparently overpowered by the intense heat and smoke, the rook hopped over to the TV aerial to cool off. It then flew back to the chimney pot for another session, preening itself all the while. Presumably, it was using the smoke to fumigate its feathers and skin to get rid of parasites such as lice, mites and ticks. Other techniques for keeping feathers pest-free and in good condition include dust-bathing and various 'anting' techniques (rolling on ants' nests to provoke the inhabitants to spray formic acid, or anointing themselves with other pungent substances). Smoke-bathing, once fairly common among intelligent corvids such as rooks, jackdaws and crows, is seldom seen these days as open fires decline. Rooks, though, have been seen fumigating themselves over smouldering cigarette butts.

Panasonic Lumix DMC-FZ200 + 108mm lens; 1/400th sec at f4; ISO 100.

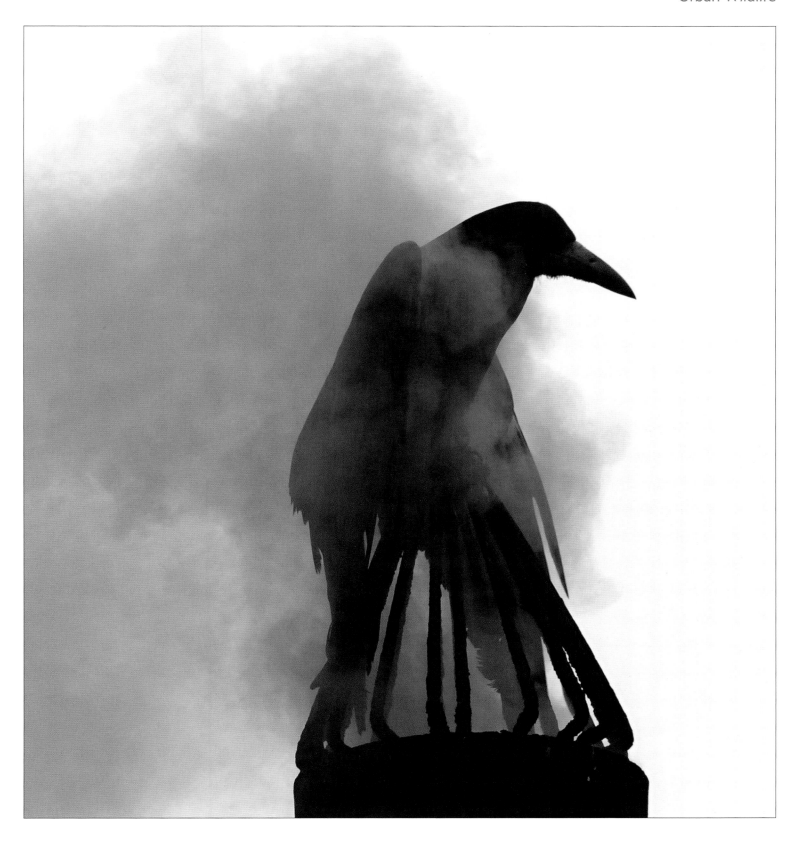

Home on the range

Karine Aigner

USA

Every afternoon, as the sun began to set, the bobcat would lead her kittens onto the deck for a drink and to relax and play. Her den was under a remote ranch house in southern Texas, where the owners regularly put out water for the birds. At first, the slightest sound or sight of a human would cause her to flee. But as spring turned into summer, and Karine patiently waited and watched from nearby, the bobcat's trust grew. In the end, she allowed Karine not only to sit on the deck but to follow them into the surrounding brush. By the end of the summer, the mother would even leave her kittens on the deck while she went off to hunt, even with Karine still there. 'We co-existed,' says Karine. 'I was there to heal from the land. She was using the human structure to raise a family. We both took refuge in each other's worlds.' Bobcats are often regarded as pests, hunted for sport and trapped for their pelts. Karine saw them as individuals, with personalities and relationships – the gutsy female, the curious male and the anxious brother. 'I watched lessons being taught, I heard them cry for their mother when she left them alone at night, and I watched them tumble out to meet her when she returned. I witnessed learning, love, fear and kinship ... The mother also taught me what trust was.'

Canon EOS 5D Mark III + 16–35mm lens; 1/800 sec at f16; ISO 1600.

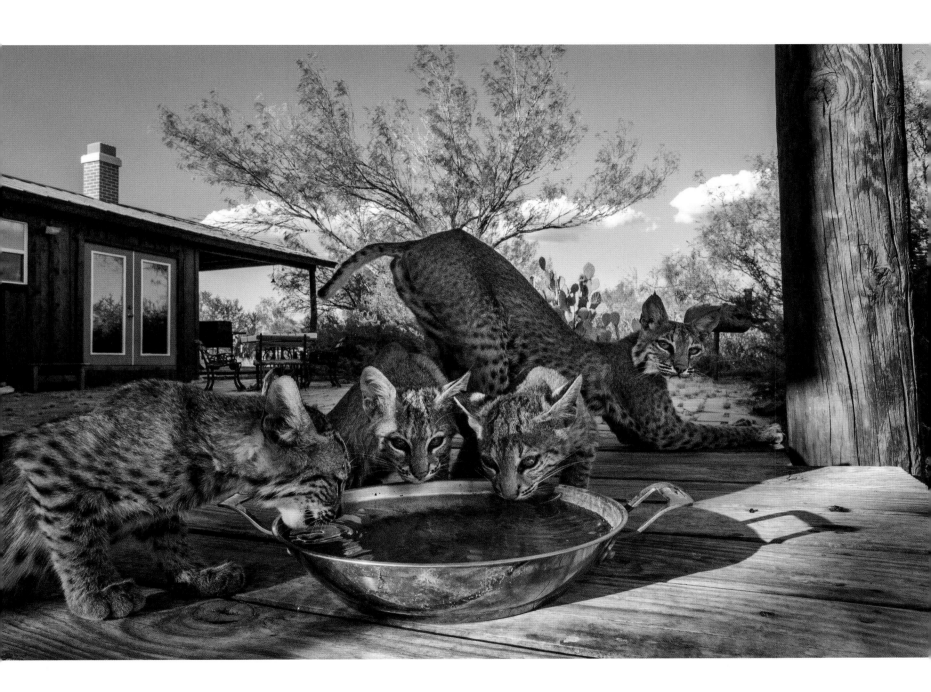

Earth's
Environments

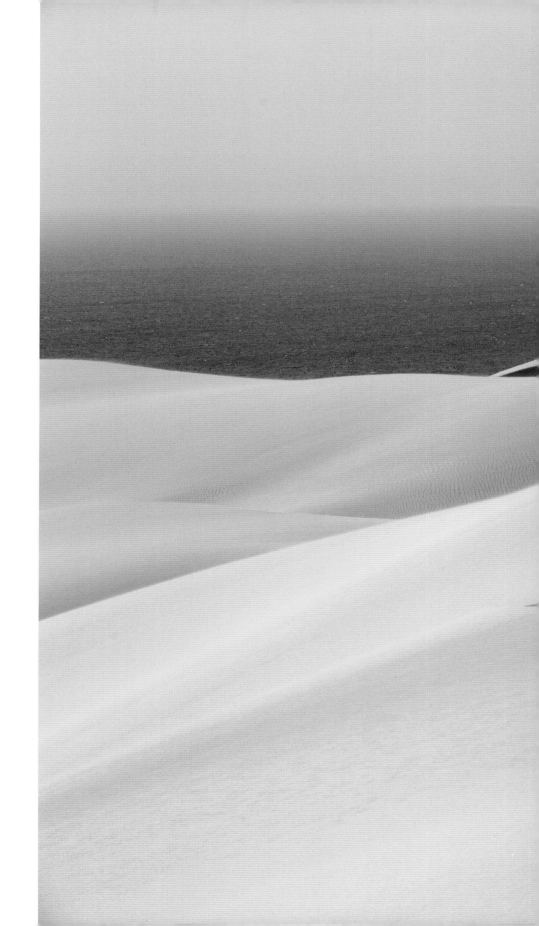

Windsweep
Orlando Fernandez Miranda
SPAIN

Standing at the top of a high dune on Namibia's desert coastline, where mounds of wind-sculpted sand merge with crashing Atlantic waves, Orlando faced a trio of weather elements: a fierce northeasterly wind, warm rays of afternoon sunshine and a dense ocean fog obscuring his view along the remote and desolate Skeleton Coast. Such eclectic weather is not unusual in this coastal wilderness. It is the result of cool winds from the Benguela Current, which flows northwards from the Cape of Good Hope, mixing with the heat rising from the arid Namib Desert to give rise to thick fog that regularly envelopes the coast. As it spills inland, the moisture from this fog is the life-blood for plants and insects in the dry dunes. Orlando framed his shot using as a focal point the sharp ridge of sand snaking out in front, ensuring that the sweep of wind-patterned dunes to his right remained in focus, and kept the distant fog-shrouded coast as a mysterious horizon.

Canon EOS 5D Mark III + 70–200mm f2.8 lens at 110mm; 1/500 sec at f11; ISO 100.

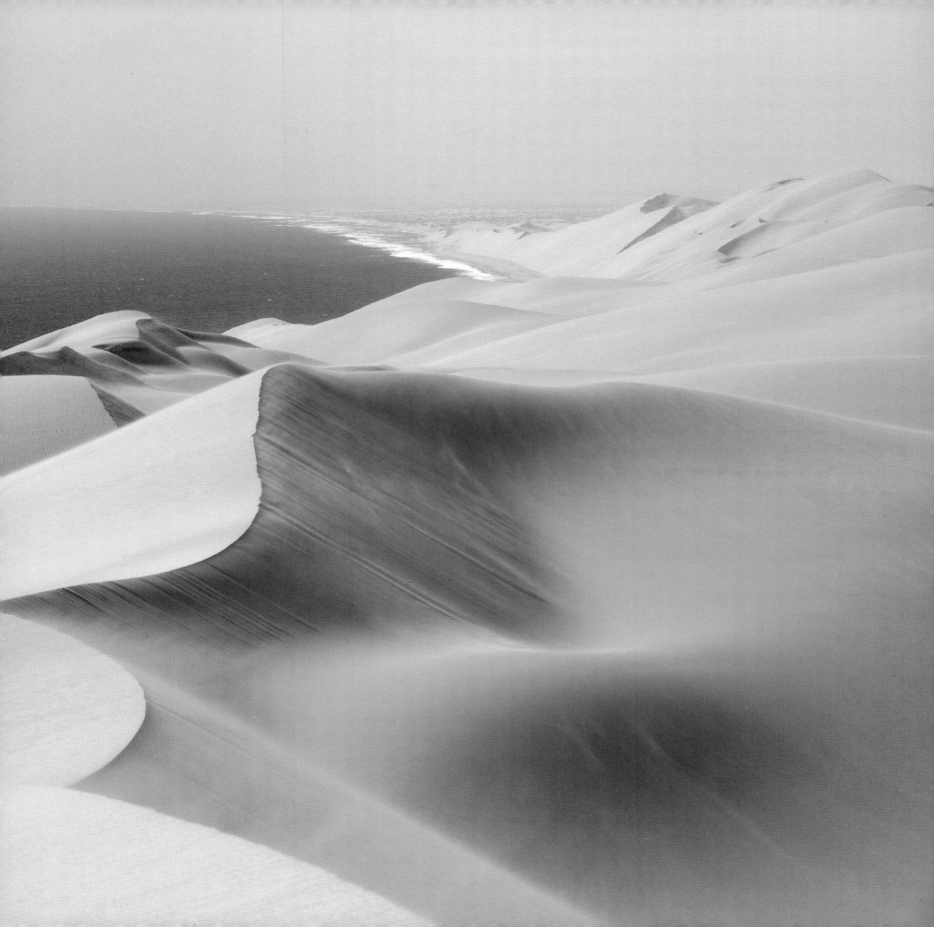

Delta design
Paul Mckenzie
IRELAND/HONG KONG

Flying over the Southern Ewaso Ng'iro River delta, on the border of Kenya and Tanzania, Paul was mesmerized by the network of tendrils, tinged green with algae, spreading through the river sediment. A far fainter latticework traced the trails made by lesser flamingos as they fed. Every year for the past 12 years, Paul has flown over the delta, observing its constant reshaping due to fluctuating rainfall and deposits of silt and sand. Flowing south through Kenya, the river empties into the caustic waters of Lake Natron in northern Tanzania, a major breeding site for lesser flamingos, which rely on the river's fresh water for drinking and for cleaning the salt from their feathers. As his small plane flew over the fern one final time, Paul framed his shot through the open door, battling against turbulence to capture nature's silt and water composition.

Canon EOS 5D Mark IV + 24–105mm f4 lens at 32mm; 1/5000 sec at f4; ISO 400.

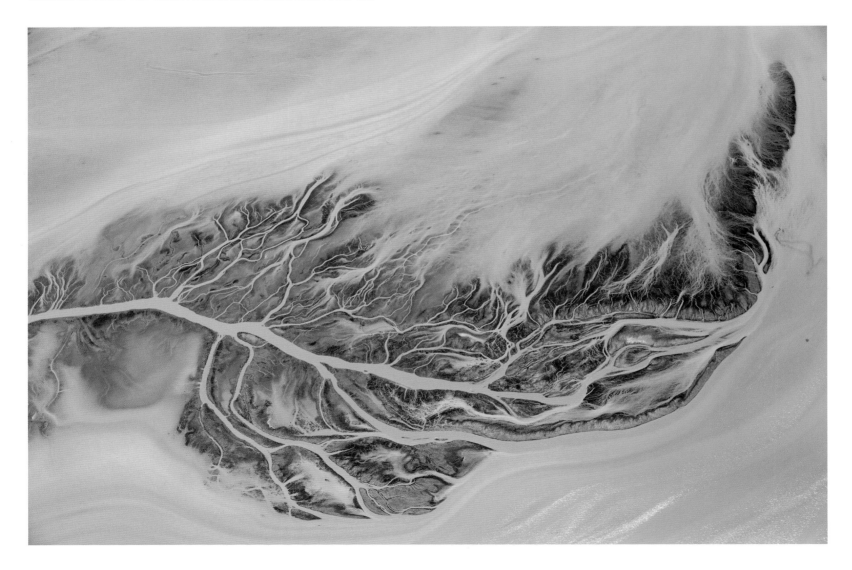

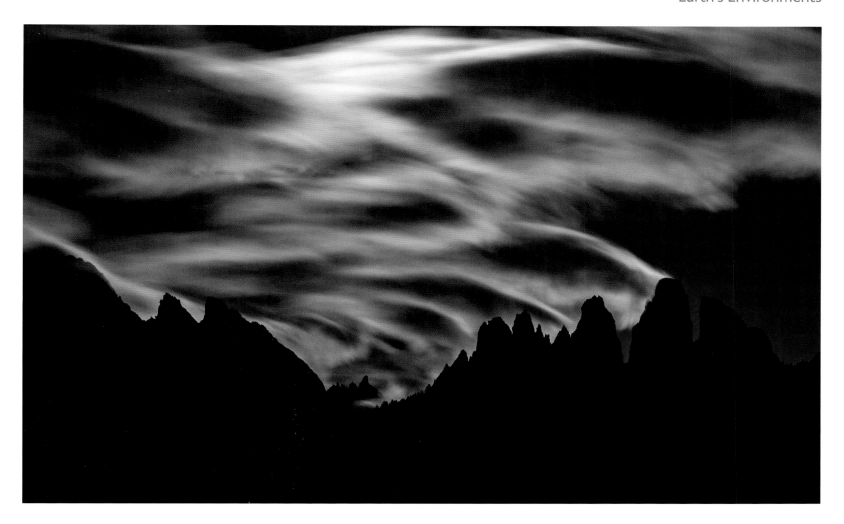

Dolomites by moonlight
Georg Kantioler

ITALY

Against an imposing jagged outline of mountain peaks, Georg watched the wind-whipped clouds scud across the night sky, backlit by moonlight. Having studied the lunar orbit, he knew that on this particular summer's evening the full moon would be positioned close to the sharp peaks of the Odle massif (aptly named 'needles' in Ladin, the local language), a compact mountain range close to his home in the Italian South Tyrol. Rising prominently between the valleys of Funes and Gardena in the Puez-Odle Nature Park, the Odle massif forms part of the UNESCO-protected Dolomites, which stretch across northeastern Italy. Tracing the movement of the luminous clouds with a long exposure of 1 minute and 45 seconds, Georg created the illusion of smoke billowing from the silhouetted summits as the clouds painted patterns across the night sky.

Canon EOS 5D Mark IV + 100–400mm f4.5–5.6 lens at 286mm; 105 sec at f16; ISO 50; cable release; Manfrotto tripod + ballhead. cable release; Manfrotto tripod + ballhead.

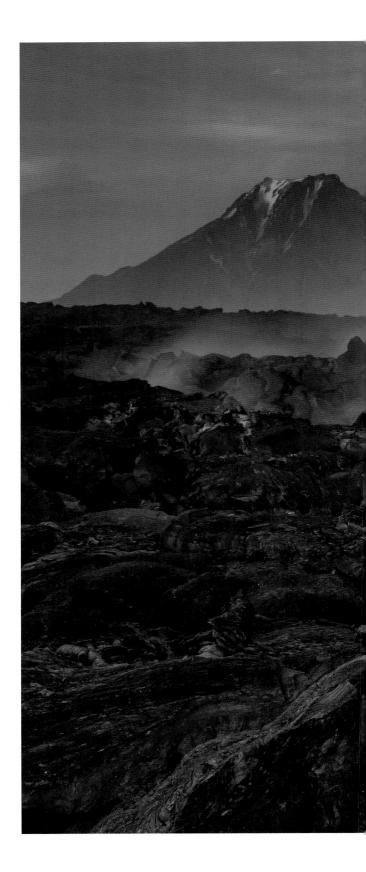

Inner fire
Denis Budkov
RUSSIA

Metres from where Denis stood, a river of red-hot lava flowed beneath the crust of the Tolbachinsky Dol lava field, on the flank of the Plosky Tolbachik volcano on Kamchatka Peninsula in the Russian Far East. Ahead, out of a deep crevice – glowing red from the extreme heat of the lava flow below – rose a thick plume of gas, like 'dragon's breath', says Denis. Getting any closer was out of the question. As the sun set behind him, casting warm light across the igneous rock and painting the clouds the same hue as the glowing crevice, he framed his shot with the Bolshaya Udina volcano in the distance. The Kamchatka Peninsula is one of the world's most active volcanic regions, with 29 of its 160 volcanoes currently active. Plosky Tolbachik began erupting in late November 2012 (36 years since its previous eruption). By the time Denis captured this image, a month before the eruption ended in September 2013, the thickness of the solidified lava beneath his feet had reached 50 metres (165 feet), while the volcano had produced lava flows extending up to 20 kilometres (12 and a half miles). Five years later, glowing lava is still visible on the lava field – though this deep crevice has cooled enough to become a huge cavern, which tourists are already visiting, despite the heat and potential danger.

Canon EOS 5D Mark III + 24–70mm lens at 32mm + ND graduated filter; 1 sec at f10; ISO 1000; Manfrotto tripod + Benro ballhead.

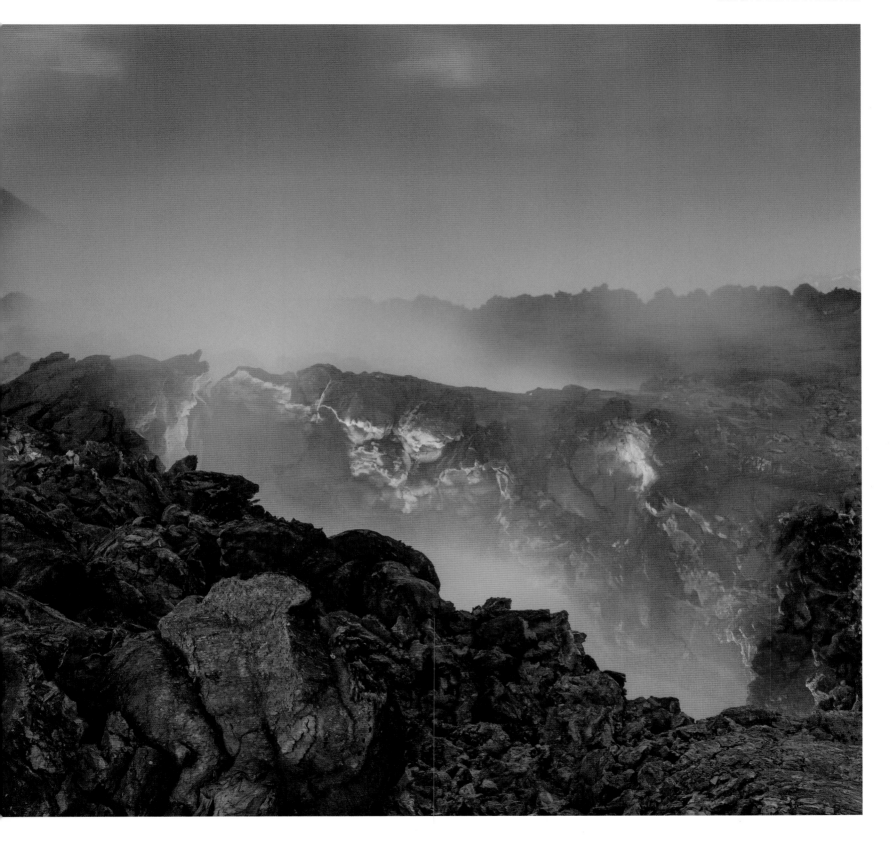

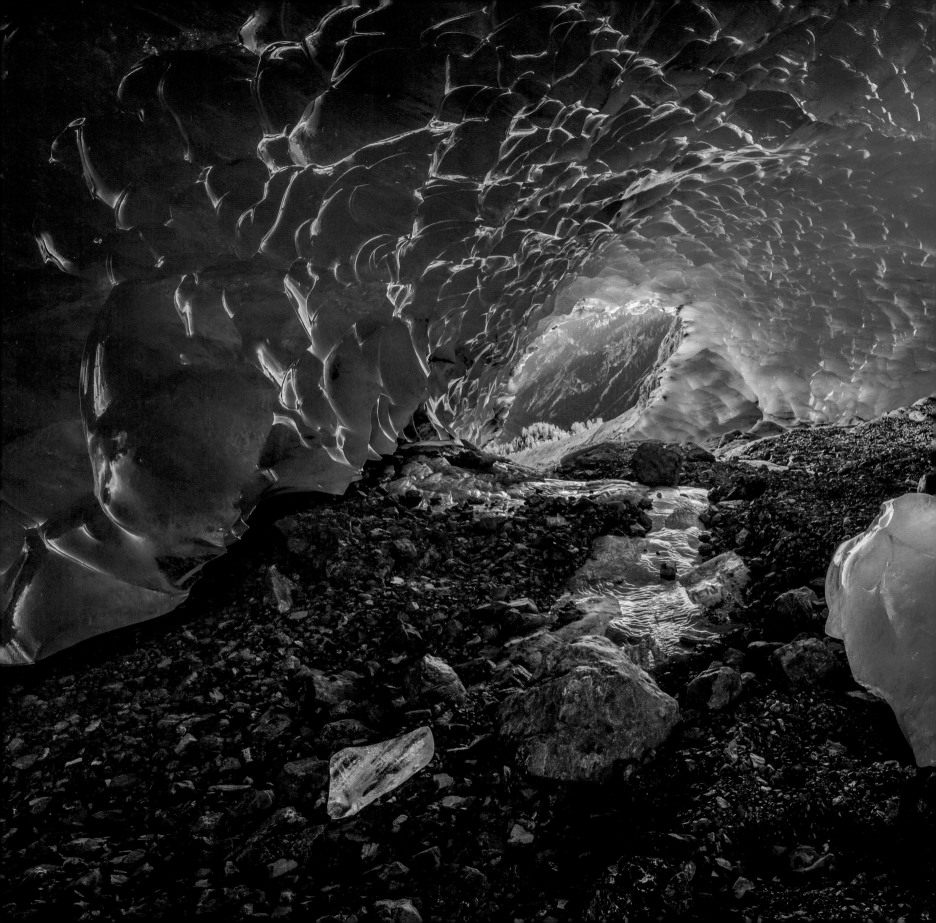

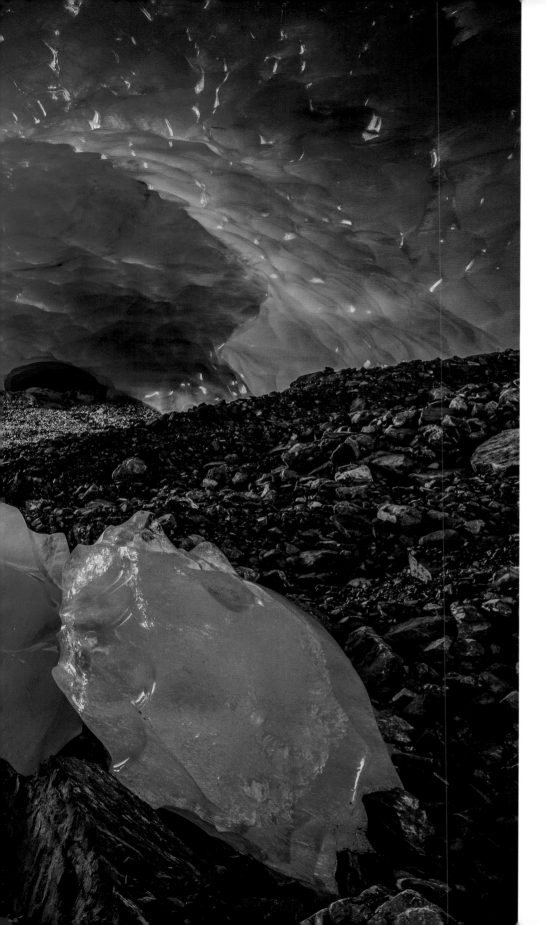

Ice-cave blues
Georg Kantioler
ITALY

With the constant sound of dripping water and the unnerving creak of the glacier shifting above, Georg tentatively entered the ice cave. Once inside he was immersed in a cool blue world. This was his fifth attempt at exploring the deep cavern that had formed beneath a glacier in northern Italy's Stelvio National Park. His previous efforts in the summer had been abandoned because high temperatures had caused excessive ice melt, making the cave too dangerous. Indeed, increasing temperatures and decreasing snow over the past three decades have greatly accelerated the glacier's shrinkage. With sunlight streaming through the main opening and a second entrance behind him filtering in additional daylight, the cave was flooded with enough natural light for Georg to capture the scene with a slow shutter speed. To get the interior of the cave, the distant larch trees illuminated in sunlight and the alpine scenery correctly exposed, he used high-dynamic range (HDR) techniques to merge the three images to create a composite that recreated a 'breathtaking, daunting experience' of being within the ice cave.

Canon EOS 5D Mark IV + Sigma 12–24mm f4 lens at 17mm; 1/5 sec at f20; ISO 200; cable release; Manfrotto tripod + ballhead.

Creative Visions

The ice pool
Cristobal Serrano

SPAIN

On a cloudy day – perfect for revealing textures of ice – Cristobal scoured the Errera Channel on the west coast of the Antarctic Peninsula. The constant current through this relatively calm stretch of water carries icebergs of all shapes and sizes. These mighty chunks of frozen fresh water have broken off (calved) from glaciers, ice shelves or larger icebergs. Their beauty – towering above the water and looming even larger beneath – is familiar, but their impact from above, less so. Selecting one that looked promising – about 40 metres (130 feet) long and rising up to 14 metres (46 feet) tall) – Cristobal launched his low-noise drone and flew it high over the top, so as not to disturb any wildlife that might be using it for resting. The drone's fresh perspective revealed an ice carving, whittled by biting winds and polar seas. Warmer air had melted part of the surface to create a clear, heart-shaped pool, within the sweeping curves of ice. The sculpture was set off by the streamlined forms of a few crabeater seals, in dark shades following their summer moult, and simply framed by the deep water.

DJI Phantom 4 Pro Plus + 8.8–24mm f2.8–11 lens; 1/120 sec at f4.5; ISO 100.

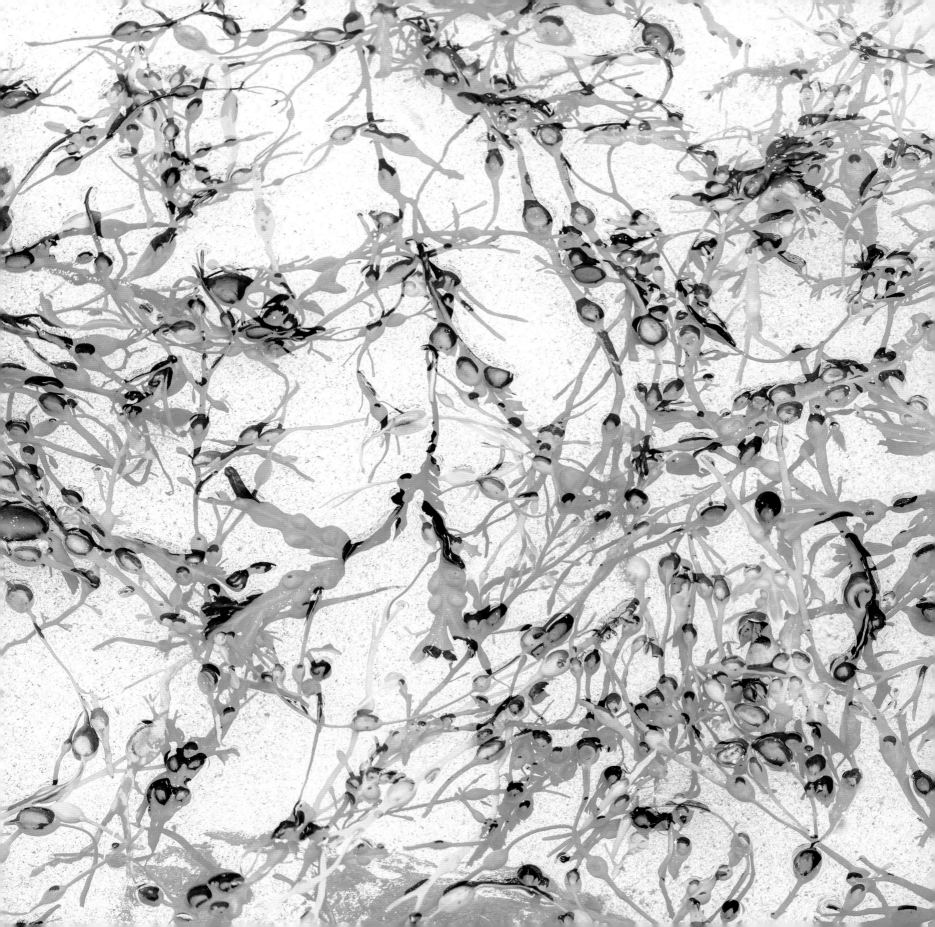

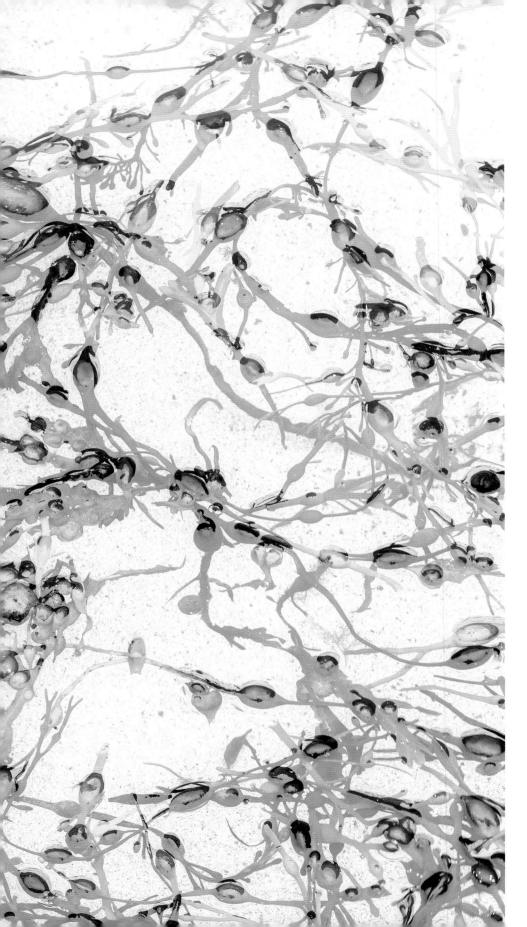

Simple beauty
Theo Bosboom
THE NETHERLANDS

In a shallow tidal pool, a colourful cluster of detached fronds of egg wrack and bladder wrack form an abstract pattern against white sand. They have been washed off the rocks surrounding Mangersta Sands, on the Isle of Lewis in Scotland's Outer Hebrides. The air-filled bladders of these marine algae keep their fronds floating and exposed to light so they can photosynthesize. Where they are very exposed to wave action, the seaweed may have no bladders, reducing the risk of them being swept away if their holdfasts are ripped from the rocks. Using a polarizing filter to avoid reflections and to reveal details beneath the surface, Theo experimented with focal lengths – while waiting for the wind to stop causing ripples and moving the seaweed. He finally settled on this composition, to reveal what he loves: 'the simple beauty of structures and patterns created by nature itself'.

Canon EOS 5DS R + 70–200mm f2.8 lens at 125mm + polarizing filter; 1/4 sec at f14; ISO 200; Gitzo tripod + Really Right Stuff ballhead.

Minuscule spicules
David Maitland
UK

Viewed through a high-magnification microscope, the minuscule calcareous spicules embedded in the skin of a sea cucumber resemble a collection of anchors. Composed of microcrystals of calcite, these rows of needle-sharp spicules – each adjoined to an anchor plate – protect the soft bodies of these marine invertebrates. They also help identify the numerous species of sea cucumbers living on the sea floor worldwide. In this section, from an old museum specimen, the large ones identify *Oestergrenia digitata*, a long, worm-like sea cucumber, collected in the sheltered bay of Luce Sands in Galloway, Scotland. Using a 'differential interference contrast' lighting system, David was able to reveal the three-dimensional nature of the tissue.

Canon EOS 5D Mark II + Olympus BX51 light microscope + 10x 0.4 objective lens; 1/6 sec; ISO 50.

The upside-down flamingos

Paul Mckenzie

IRELAND/HONG KONG

Reflected on the still surface of Lake Bogoria, lesser flamingos move with synchronicity through the shallow waters of this alkaline-saline lake in Kenya's Great Rift Valley. For a photographer who enjoys creating photographs that challenge initial perceptions, Paul was drawn to the clear reflection of the birds and the pink shades of the flock – it was a scene ripe for some experimentation. Lying prone in a quagmire of thick mud on the lakeshore, he spent an hour slowly edging closer, while watching the orchestrated movement of the flamingos as they bowed their long necks to dip their bills upside down in the salty water to filter out their microscopic food – blue-green algae (cyanobacteria) – before lifting their heads in unison to move on a short distance for more filter-feeding. Focusing on the birds' red legs and framing the shot to include the reflection of the upright birds, Paul rotated the image 180 degrees in post-production to create a more abstract, reflective image.

Canon EOS 5D Mark IV + 600mm f4 lens; 1/1600 sec at f9; ISO 1250; Canon angle finder + Visual Echoes panning plate.

Black and White

The vision

Jan van der Greef

THE NETHERLANDS

Perfectly balanced, its wings vibrating, its tail opening and closing, with its tiny feet touching the spike for just an instant, an eastern mountaineer hummingbird siphons nectar from the florets of a red-hot-poker plant, or torch lily. Positioned by the flower, Jan had anticipated the bird's behaviour. For a number of days he had been stationed in the garden of his hotel in southern Peru, observing hummingbirds. He noticed that an eastern mountaineer – a species found only in Peru, characterized by its long, black-and-white forked tail – would rotate around the red-hot-poker spikes as it fed. He also saw that, when the bird moved behind a spike and its tail closed for a moment, a beautiful cross appeared. Determining to capture this strange vision, he staked out a spot underneath a single red-hot-poker plant (native to Africa, where it is pollinated by nectar-drinkers such as sunbirds). It proved to be the hummingbird's preferred garden source of energy-rich nectar. The low position of his wheelchair allowed him to set the spike against the sky, framing it with a dark surround of bushes. It took two half days to get the perfect shot, setting his camera to capture 14 frames a second, as the cross appeared for just a fraction of a second before its creator, with a burst of power, went on to the next flower on its route.

Canon EOS-1D X Mark II + 500mm f4 lens; 1.4x III extender; 1/5000 sec at f5.6; ISO 4000; Gitzo tripod + Jobu gimbal head.

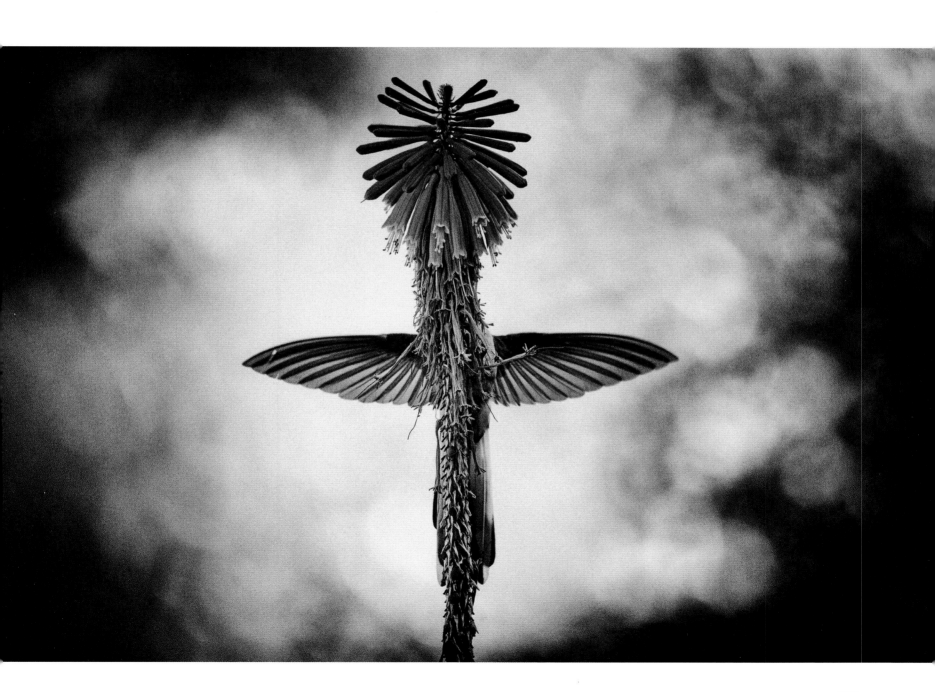

Ghost colony

Jayesh Joshi

INDIA

Extending into the horizon were thousands of abandoned lesser flamingo nests, the chalky white eggs like spots of ghostly light. In 2015, when Jayesh visited the Little Rann of Kutch – a salt desert in the Indian state of Gujarat – scant rain during the previous monsoon season had resulted in the salt marshes near this large breeding colony drying up too soon and the early return of saltpan workers to the area. With no water, little food and the threat of human interference, the adult flamingos had no choice but to desert their eggs.
On seeing the abandoned nest site, Jayesh was struck by both horror and awe. Using a small aperture to create a deep area of focus, he framed his shot to emphasize the sheer size of the colony and the extent of the mass abandonment. He also shot in black and white to convey the ghostly mood of the place.

Canon EOS 6D + 24–105mm f4 lens at 90mm; 1/50 sec at f22; ISO 100; Gitzo tripod + Manfrotto ballhead.

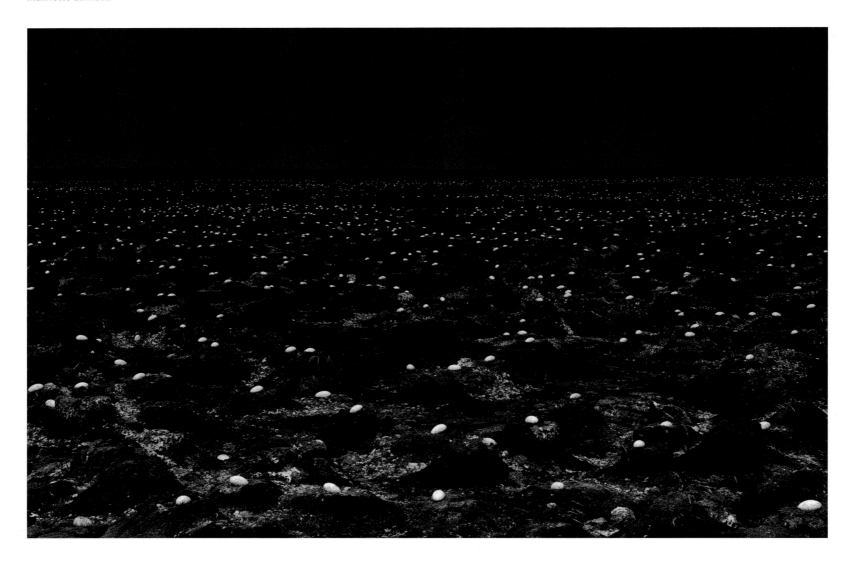

The curious calf

Christopher Swann

UK

To get a look at the humans, the grey whale calf surfaced right next to Christopher's little boat. As it did so, clouds whipped across the sky, giving an unexpected texture bonus. Normally, Magdalena Bay, on the west coast of Mexico's Baja California, is sunlit. Its warm, shallow water provides the perfect birthing area and nursery for grey whales. Shooting in black and white accentuated the smooth, dimpled texture of the calf's head, its skin yet to be encrusted with the barnacles and whale lice seen on adults. Much of its head is mouth. Hanging from the upper jaw are baleen plates, used for filtering out krill and other small prey. But for now, the calf only feeds on its mother's rich milk. Once it has built up its fat reserves and is strong enough, its mother will lead it on a journey up the Pacific coast to feeding grounds in the Arctic, where she can regain the third of her body weight lost during the winter breeding season.

Nikon D200 + 12–24mm f4 lens at 12mm; 1/200 sec at f14; ISO 200.

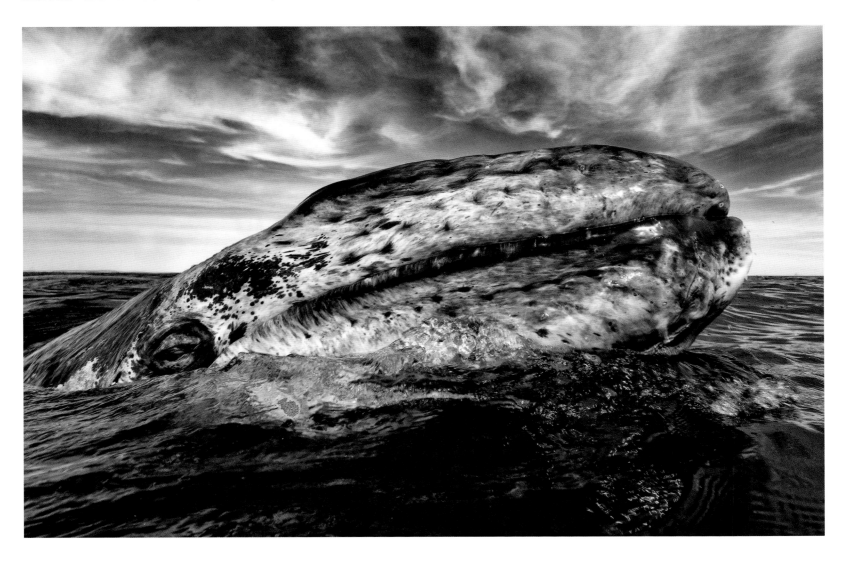

Wildlife Photojournalism

The sad clown
Joan de la Malla

SPAIN

Timbul, a young long-tailed macaque, instinctively puts his hand to his face to try to relieve the discomfort of the mask he has to wear. His owner is training him to stand upright so that he can add more stunts to his street-show repertoire (the word Badut on the hat means clown). When he's not training or performing, Timbul lives chained up in his owner's yard next to a railway track in Surabaya, on the Indonesian island of Java. Should he show aggression as he gets older, his teeth might be pulled out or he will just be disposed of. Macaque street shows are banned in several cities, but still take place elsewhere in Indonesia. The macaques often work for hours performing tricks such as dancing and riding bikes. When the owners themselves aren't working, they might rent out the monkeys. Animal-welfare charities are working at both political and community level to reduce the suffering of these monkeys and to enforce legislation that makes it illegal to take young monkeys from the wild or trade in them without a permit. But the welfare issues reflect other, deeper problems of social justice. Joan spent a long time gaining the trust of the monkey owners in Surabaya. 'They are not bad people,' he says, 'and by doing street shows, they can afford to send their children to school. They just need other opportunities to make a living.'

Nikon D810 + 24–70mm f2.8 lens; 1/250 sec at f2.8; ISO 100; Speedlight SB-800 flash.

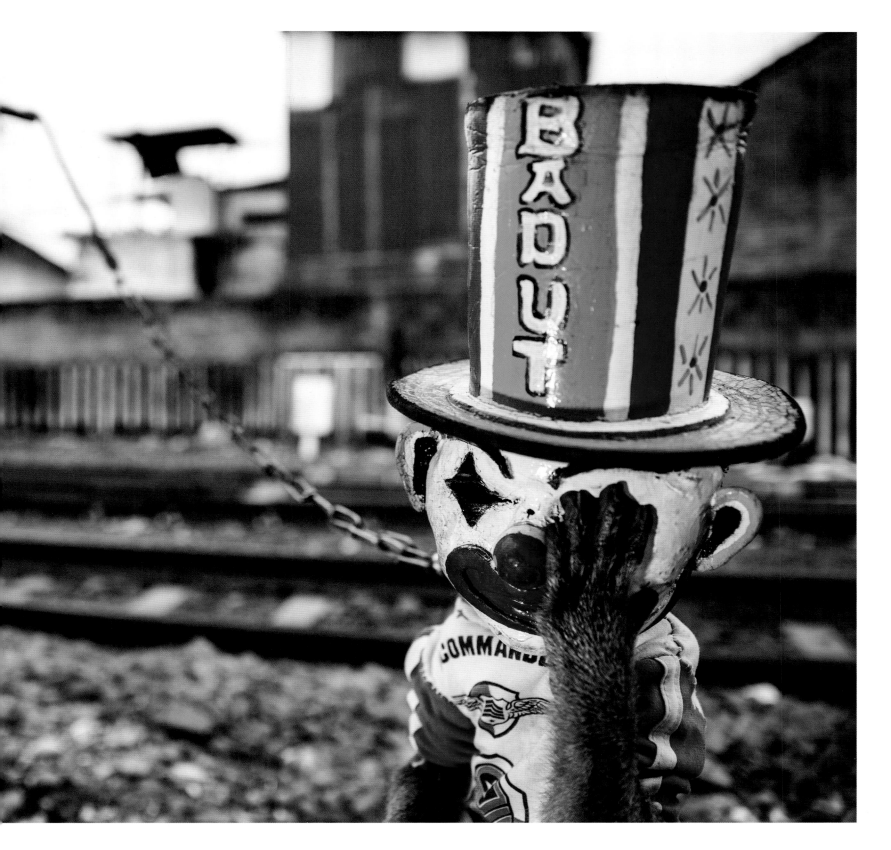

Late-night feed
Susan Scott

SOUTH AFRICA

At the Thula Thula Rhino Orphanage in South Africa, black rhino orphans Nandi and Storm, warmed by infrared lamps, guzzle the milk that carer Axel Tarifa has prepared for their 2am feed. For Storm, the stress of losing his mother (presumed to poachers) has stunted his growth – he's actually older than Nandi, the larger, female calf. Black rhinos are critically endangered – as few as 4,000 may remain – due to poaching as a result of the rising demand in China and Vietnam for rhino horn, for its supposed medicinal properties and, now, status. In South Africa, more than 1,000 rhinos are being killed annually, in particular white rhinos – estimated population under 20,000. Nine months after this picture was taken, the orphanage was attacked. Axel was assaulted, and two older white rhino orphans slaughtered. Nandi and Storm, their horns too small to be worth the trouble, were spared. But the orphanage has had to close, and the calves have been moved to a secret location.

Canon EOS 7D Mark II + 17–55mm f2.8 lens; 1/45 sec at f2.8; ISO 3200.

Unbearable
Britta Jaschinski

GERMANY/UK

The audience cheered as the Asiatic black bear performed its tricks at Guilin's
Seven Star Park in China, including riding a bike and walking a tightrope.
The pushes and blows this bear endured on stage were a fraction of the
likely suffering behind the scenes. Performing animals are kept in appalling
conditions and may also be starved and then rewarded with food during the
show to ensure compliance. In 2010, the Chinese authorities banned wild-animal
performances at zoos, but an investigation by Animals Asia found that, in 2016,
nearly 100 zoos and animal parks surveyed (39 per cent) were not complying
with the legislation. Animal acts also continue in safari parks and travelling circus
shows. This is a conservation issue, too, as many of the animals are captured
from the wild. Asiatic black bears are in decline throughout much of their range
due to habitat loss and widespread illegal killing for their body parts.

Nikon F4 + 50mm lens; 1/125 sec at f5.6; Kodak Tri-X-Pan 400 film.

Beach waste
David Higgins
UK

A dead sperm whale more than 14 metres (46 feet) long is dragged across a beach by a digger near Skegness on the UK's Lincolnshire coast, to begin its journey to a landfill site. It was one of 29 sperm whales, mostly males, that in early 2016 stranded in the south of the North Sea. Five of them died on the east coast of England and the rest on the coasts of Germany, the Netherlands and France. It's not clear why the whales swam into the North Sea, but one theory is that solar storms disrupted the Earth's magnetic field, affecting the sperm whales' navigation and causing them to turn south instead of continuing to feed on squid in the deeper Norwegian waters. Once sperm whales travel south of the North Sea's Dogger Bank, they enter very shallow water and almost invariably strand. Their sheer size and weight mean their lungs collapse if they are forced onto a sand bank or mudflat. When four of the whales stranded in Germany were examined, they were found to have large amounts of plastic waste in their stomachs, including a large shrimp net, though this was not the direct cause of the stranding. Aside from solar storms and anomalies in the magnetic field around coastlines, the reasons for stranding can involve human activity, including seismic surveys and military sonar. But by far the greatest cause of deaths off the UK coast is entanglement in fishing gear.

Canon EOS 5D Mark III + 70–200mm f2.8 lens at 105mm; 1/125 sec at f7.1; ISO 500; Manfrotto monopod.

Witness
Emily Garthwaite
UK

As soon as he saw Emily, the sun bear hurried to the front of his filthy cage. 'Every time I moved, he would follow me.' He was just one of several sun bears kept behind the scenes at a zoo in Sumatra, Indonesia, in conditions Emily says were 'appalling'. Sun bears are the world's smallest bears, now critically endangered. In the lowland forests of Southeast Asia, they spend much of their time in trees, eating fruit and small animals, using their claws to prise open rotten wood in search of grubs. They are threatened by rampant deforestation and the demand for their bile and organs for traditional Chinese medicine. People involved in illegal logging and clearance for oil palms are also linked to animal trafficking. When this sun bear saw the keeper, he started screaming. It was a chilling noise. Even more chilling was the nearby taxidermy museum with its stuffed pangolins and Sumatran tigers.

Leica M240 + Zeiss Distagon T* 35mm f2 lens; 1/125 sec at f5.6; ISO 1000.

Autopsy
Antonio Olmos
MEXICO/UK

A young Siberian tigress is laid out, awaiting an autopsy. Her emaciated body was found under a car on the outskirts of a town in the Russian Far East, near the border with China. She was missing a forepaw. Undoubtedly, she had chewed off her own foot after being caught in a poacher's trap. Unable to hunt, she would have slowly starved to death. The Siberian (or Amur) tiger subspecies was once found throughout the Russian Far East, northern China and the Korean Peninsula. Hunted almost to extinction, protection in Russia has increased its population there to possibly more than 540. The harsh environment means that, to find enough prey, Siberian tigers need a huge home range, the largest of any tiger subspecies. But poaching – for their skin and bones, but also of their prey – remains a threat, compounded by illegal logging of their pine forest.

Canon EOS 5D Mark IV + 24–70mm f2.8 lens; 1/125 sec at f5.6; ISO 400.

One in a million
Morgan Heim

USA

A young black-tailed doe lies beside a road in Oregon, as though in mid-leap. More than a million vertebrates are killed every day on the roads of the US. Many others crawl away to die unseen. The value of individual lives lost is erased by economic statistics – collisions with deer cost more than $5.6 billion. The deaths are so mundane that 'we drive by with barely a glance', says Morgan. She borrows human rituals to pay tribute to the victims she finds: the funeral wreath, the roadside memorial and the 'death portrait'. In the case of this doe, she arranged flowers around the body as she found it, bathed it in colour by shining a pen torch through a coloured plastic bag and used the headlights of a passing car to add a brief, fitting spotlight. She says that, with these memorials, 'I want people to slow down, to look and to add support for the solutions that will help save lives.'

Sony a9 + Canon 16–35mm f2.8 lens; Metabones adaptor; 30 sec at f11; ISO 500; coloured bag + penlight; Benro tripod.

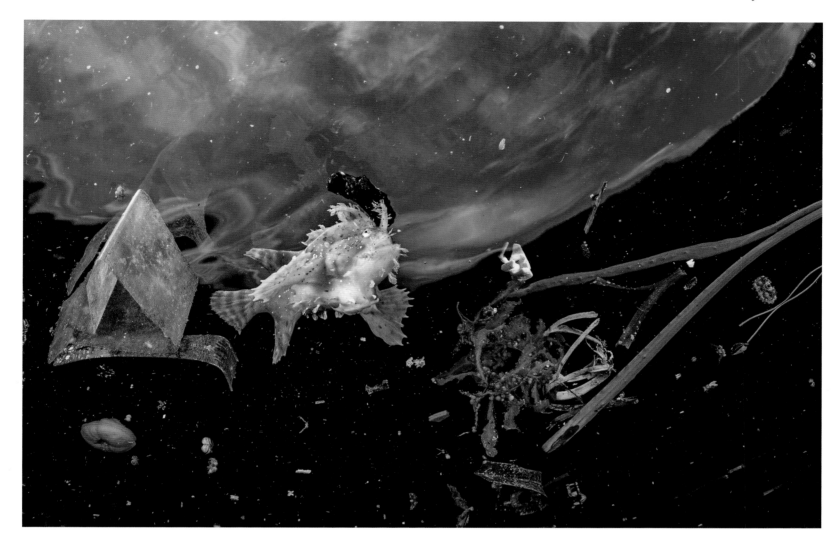

Life among litter
Greg Lecoeur

FRANCE

This Sargassumfish couldn't hide among the litter. The nearby frond of Sargassum seaweed was a far cry from the free-floating rafts of the seaweed that more normally shelter this frogfish and many other specialized species. A master of camouflage and an ambush predator, the Sargassumfish stalks its prey on claw-like fins through the fronds of these floating islands, concealed by its tan colour and feathery outline. Greg spotted this individual when returning from a dive on the biodiverse reefs of the Indonesian archipelago of Raja Ampat. It is an area of the western Pacific Ocean where strong currents converge, bringing with them nutrients that sustain the rich biodiversity. The currents also collect and concentrate anything else that floats – including some of the millions of tons of plastic that end up in the oceans each year.

Nikon D7200 + Tokina 10–17mm lens; 1/250 sec at f11; ISO 100; Nauticam housing NAD7200; two Ikelite DS161 strobes.

Wildlife Photojournalist Award

The award is given for a story told in just six images, which are judged on their storytelling power as a whole as well as their individual quality.

Alejandro Prieto
MEXICO

GUNNING FOR THE JAGUAR

In Mexico, working with the conservation foundation Jaguar Alliance, Alejandro has been creating pictures that can be used to influence and inspire the communities where the big cat still exists. Outside its Amazonian stronghold, the jaguar is endangered everywhere in the Americas. In Mexico, in just two decades, its numbers have halved to fewer than 3,500. Preventing further fragmentation of the remaining jaguar habitat, whether mountain forest or mangrove swamp, says Alejandro, is the only way to save Mexico's last jaguars.

Signature tree

A male jaguar sharpens his claws and scratches his signature into a tree on the edge of his mountain territory in the Sierra de Vallejo in Mexico's western state of Nayarit. The boundary-post has been chosen with care – the tree has soft bark, allowing for deep scratch marks that are a clear warning, backed by pungent scent, not to trespass. Alejandro set up his custom-built camera trap some 6 metres (20 feet) up the tree and returned every month to change the batteries. Eight months elapsed before the jaguar eventually returned to this corner of his realm to refresh his mark. Jaguars need vast territories to have access to enough prey. But in Mexico, habitat is being lost at a rapid rate as forest is cleared for crops or livestock or for urban development, and much of what remains is fragmented. The loss of even a small area of habitat can cut a jaguar highway between one part of a territory and another and isolate the animal to such an extent that it cannot feed itself or find a mate.

Nikon D3300 + Sigma 10–20mm lens; 1/200 sec at f9; ISO 200; home-made waterproof camera box; two Nikon flashes + plexiglas tubes; Trailmaster infrared remote trigger.

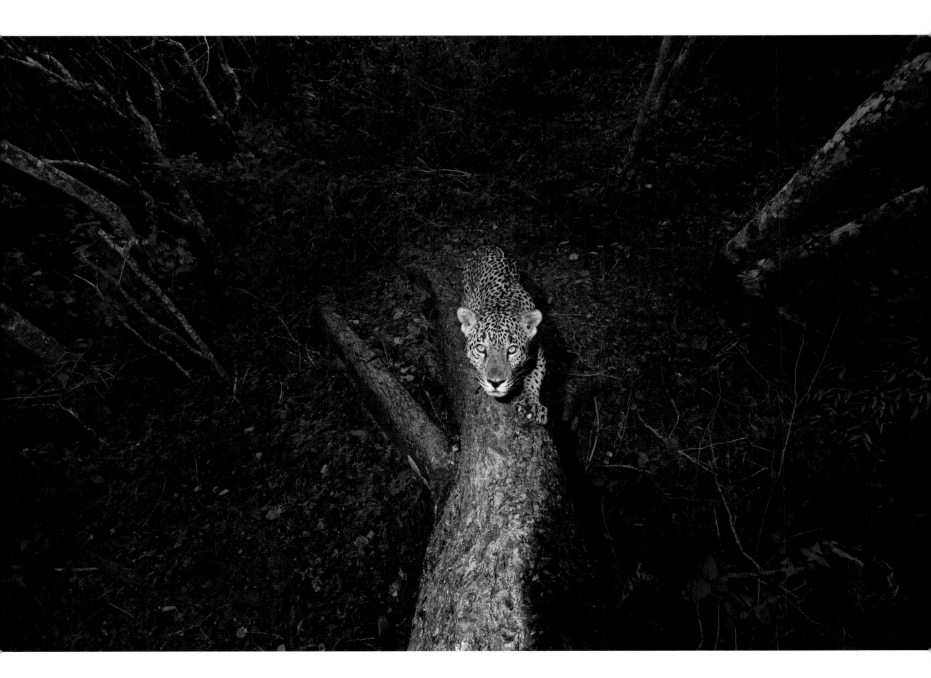

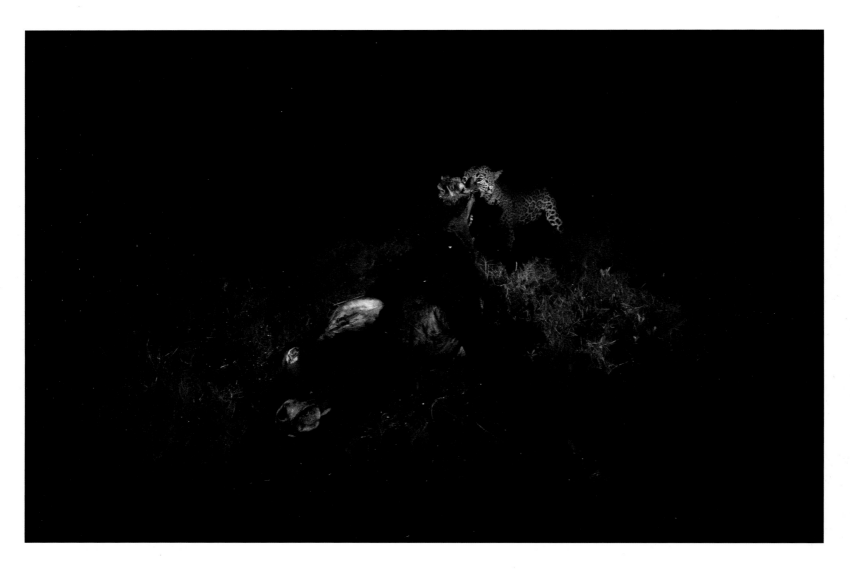

Cats for cows

Conflicts with cattle ranchers are, after habitat loss, the greatest threat to the jaguar's survival. When ranchers encroach on forest occupied by jaguars, illegal hunting becomes rife, wiping out the jaguar's prey, mainly deer, peccaries and coatis. Cattle also roam through the jungle, competing for food with the wild herbivores. Natural prey becomes scarce, and eventually the jaguar attacks a cow. Normally it eats only part of the animal and then returns a day or so later to finish its meal, by which time ranchers may have laced the carcass with poison or are waiting with a shotgun. 'When a jaguar kills a cow, it's usually a death sentence,' says Alejandro. Some ranchers just go ahead and kill jaguars to avoid any chance of losing cattle in the first place. The owner of this cow invited Alejandro to come and wait for the jaguar to return to finish its meal. 'People kill the jaguar's prey; without prey the jaguar kills cattle; then people kill the jaguars. It's a vicious circle.'

Nikon D3300 + Sigma 10–20mm lens; 1/200 sec at f8; ISO 200; home-made waterproof camera box; two Nikon flashes + plexiglas tubes; Trailmaster infrared remote trigger.

The good hunter

Enraged, the young male jaguar lunged at scientist Rodrigo Nuñez, who had just injected him with a needle attached to a bamboo stick. But the cable snare around his front paw held, and the jaguar rapidly succumbed to the sedative, allowing Rodrigo to check his health and fit him with a GPS collar. Rodrigo has dedicated his life to protecting jaguars, and this was a rare opportunity to catch and collar one. Jaguars roam so widely that it can be weeks or months before they return to the same area. In the state of Nayarit in western Mexico between the forested mountains of the Sierra Madre Occidental and the Pacific Ocean, numbers of jaguars are decreasing alarmingly, mainly because of hunting. Many bullets were buried in this jaguar's side, and two of his teeth had been shattered after he had been shot in the face. Tracking jaguar movements helps scientists identify where corridors of habitat could be created to link fragmented forest so that jaguars can find enough food and connect with mates. Rodrigo tracked this jaguar for five months – and then the collar stopped transmitting. He presumes the jaguar was killed by hunters, who then destroyed the collar.

Canon EOS 5D Mark II + 16–35mm f2.8 lens; 1/125 sec at f4; ISO 3200.

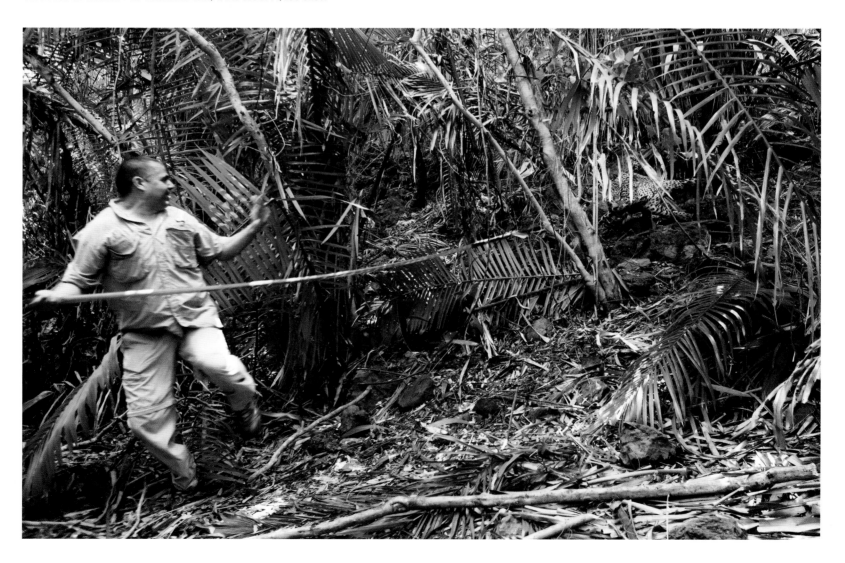

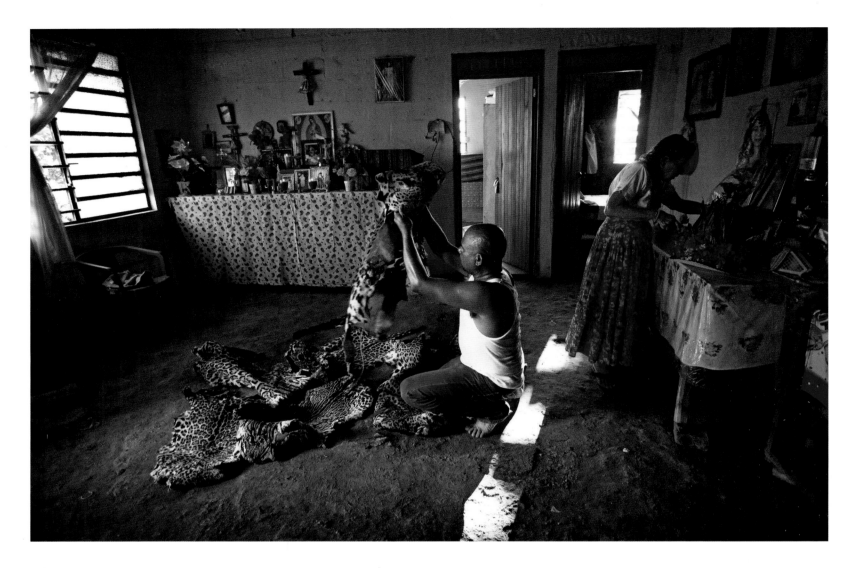

Remains of the past

There were eight jaguar skins among the pelts in this house, in a small town
in the forested state of Campeche on the Yucatán Peninsula. There may be as
many as 600 jaguars in this region, but they are heavily hunted, for reprisal,
sport or trade. While the market for pelts has fallen in the wake of anti-fur
campaigns, the demand for paws and teeth (for jewellery) continues, and
jaguar bone is starting to augment tiger bone in traditional Asian medicine.
'I often heard about people coming to small towns in Mexico in search of wildlife
products, including jaguar parts,' says Alejandro. Those involved in the illegal
trade have little to fear from the law, unless they are caught in the actual act of
killing a jaguar. Conservationists focus instead on broader, integrated approaches
to protecting jaguars, concentrating on habitat protection, education,
ecotourism, sustainable development, cultural respect and community support.
As a member of the Jaguar Alliance, Alejandro uses his images to give talks to
communities in small towns. 'I try to change the ideology that glorifies hunting.'

Canon EOS 5D Mark II + 16–35mm f2.8 lens; 1/160 sec at f5; ISO 400.

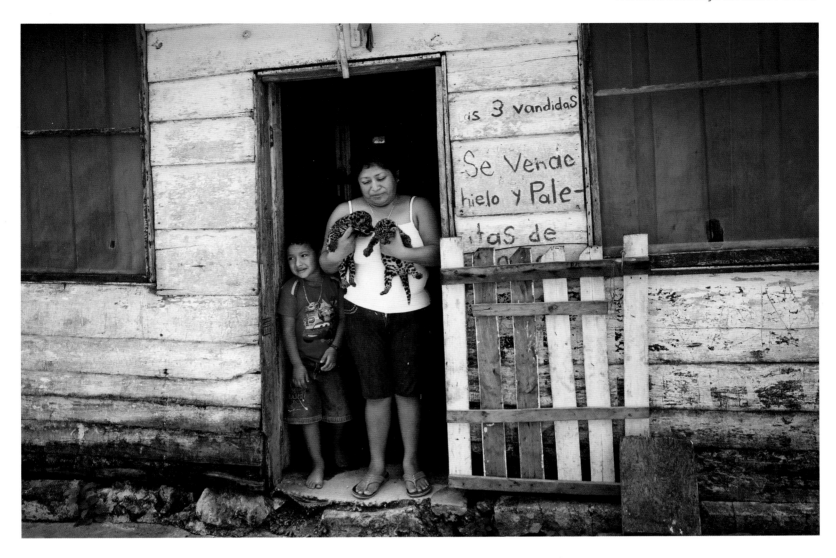

Hope for the future

Two four-week-old female jaguar cubs are about to be handed over to the authorities in a small jungle town on the Yucatán Peninsula, southern Mexico. A poacher probably killed their mother and sold the cubs to this woman, who would have sold them on as pets. They were lucky to have survived without their mother's milk, since jaguar suckle their cubs for five to six months. Young jaguars also stay with their mothers until they are about two years old and have learnt to hunt. These cubs were taken to a jaguar refuge that specializes in keeping animals as wild as possible, training them to hunt. The pair are now nearly two years old and so ready to be released if suitable protected forest can be found. A female jaguar will breed every seven to eight years, but with much of their habitat now fragmented, it is becoming harder for males and females to find each other. So keeping jaguar highways open between populations is vital. Small, isolated populations run the risk of becoming inbred and may not be able to recover from catastrophic events such as fires or epidemics.

Canon EOS 5D Mark II + 16–35mm f2.8 lens; 1/4000 sec at f4.5; ISO 800.

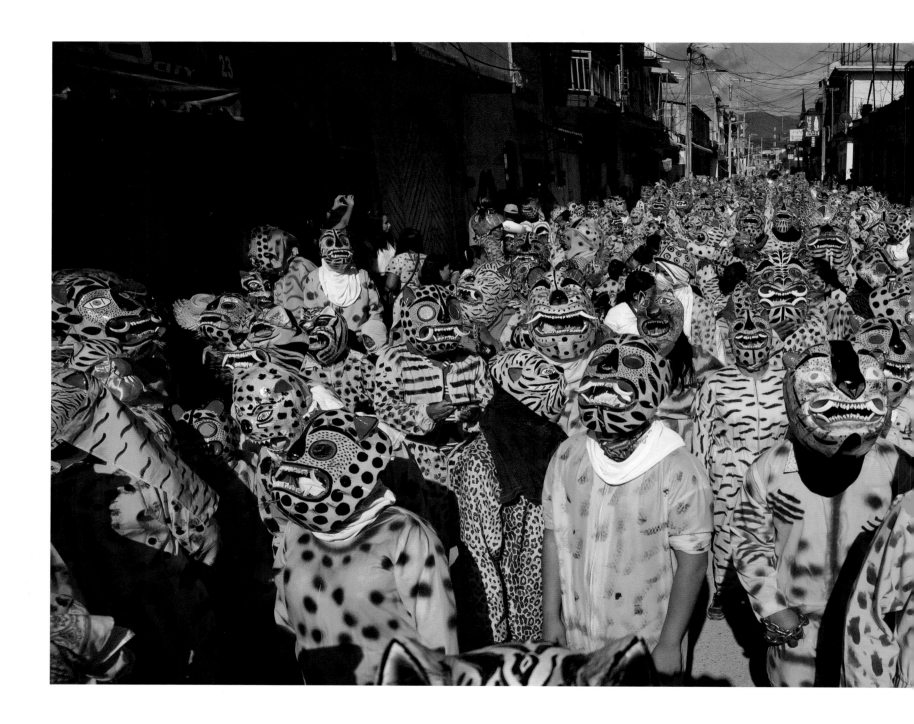

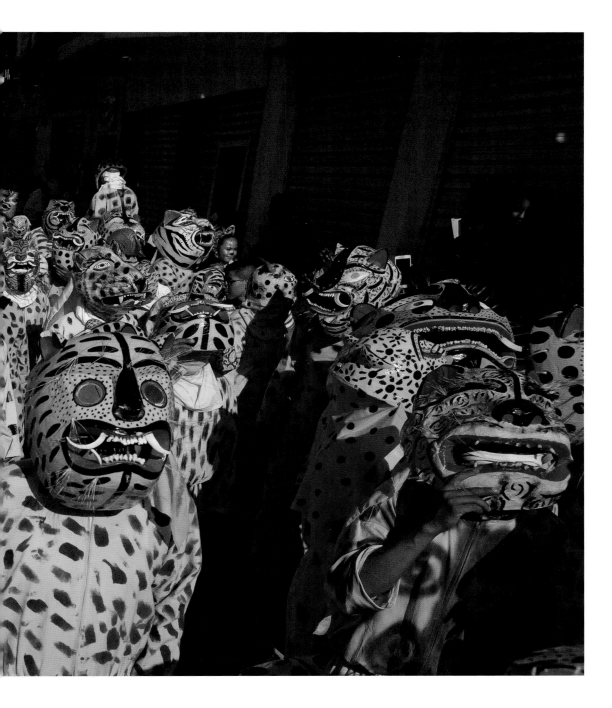

Jaguars come to town

More than 1,000 people parade in vibrant fancy dress to celebrate the jaguar. The Tigrada festival is held every August in Chilapa de Alvarez, an ancient town in the southwestern state of Guerrero. The participants make their own wooden masks, mostly decorated with peccary teeth and hair and with mirrors for eyes. The parade, the music and the dances invoke the Aztec god Tepeyollotl, represented by a jaguar, calling for more rain and abundant crops. The festival is called Tigrada because sixteenth-century Spaniards, who had never encountered jaguars, called them tigers. The jaguar has long been a major element of Mexican culture and mythology, featuring heavily in the art and artefacts of the ancient civilizations of the Aztecs, Mayans and Olmecs. Today, La Tigrada is the biggest celebration of an animal in Mexico. But the jaguar itself is extinct in this particular region.

Canon EOS 5D Mark II + 16–35mm f2.8 lens; 1/5000 sec at f6.3; ISO 800.

Wildlife Photojournalist Award

Jasper Doest

THE NETHERLANDS

MEET BOB

Bob is a Caribbean flamingo, from the Dutch island of Curaçao. His life took a dramatic turn when he flew into a hotel window, leaving him severely concussed. He was cared for by the photographer's cousin, Odette Doest, a local vet who also runs a wildlife rehabilitation centre and conservation charity – the Fundashon Dier en Onderwijs Cariben (FDOC). Existing disabilities meant Bob couldn't be released, but instead he became an ambassador for FDOC, which educates locals about the importance of protecting the island's wildlife.

Lap-bird

Bob sits in Odette's lap as she drives him around the island of Curaçao promoting the work of FDOC – which she started in 2016, the year Bob was rescued. It turned out that Bob was already habituated to humans, and had probably been kept captive on concrete, as he had developed bumblefoot – a condition that causes painful lesions and growths under a bird's feet. So he couldn't be returned to the wild – to the island's salt flats, where a colony of 200–300 flamingos lives. But now his public appearances help promote the welfare and conservation of his wild relatives.

Leica M-P + 21mm f3.4 lens; 1/180 sec at f16; ISO 500.

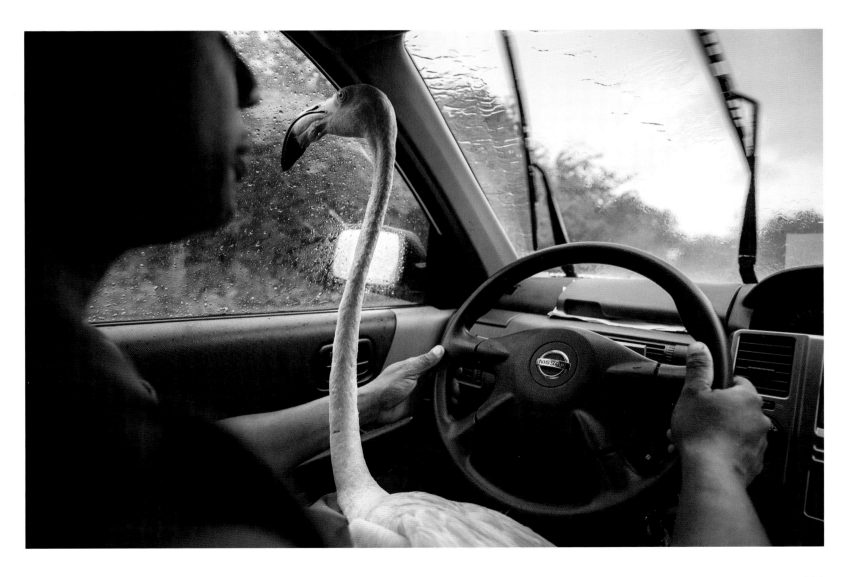

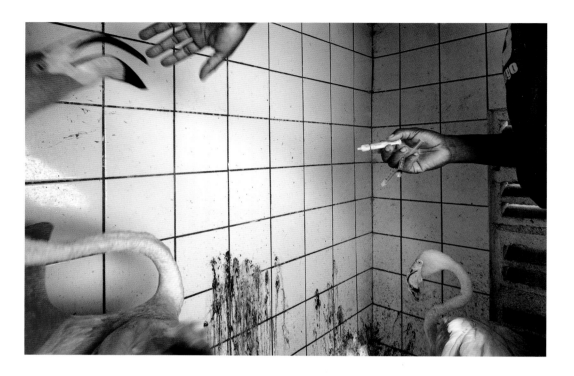

Attending to George

While Odette administers antibiotics to George, a flamingo found with a broken wing following a suspected dog attack, Bob lingers close by. Stress is always a problem in wildlife rehabilitation, but Odette believes that the presence of Bob makes new arrivals feel more at ease. And with Bob in the same enclosure, George settled down within a day and learned from Bob how to feed from a bucket.

Leica M10 + 21mm f3.4 lens; 1/45 sec at f11; ISO 800.

Wing-mending

George undergoes surgery to his broken right wing in Odette's veterinary practice. Besides safely capturing and treating wild animals, rehabilitation involves regulated feeding, physical therapy and a pre-release conditioning programme. When the animals are well enough to be returned to the wild, it has to happen in the right habitat, location, season and even weather conditions.

Canon EOS 5D Mark IV + 35mm f1.4 lens; 1/125 sec at f10; ISO 12,800; Profoto flash.

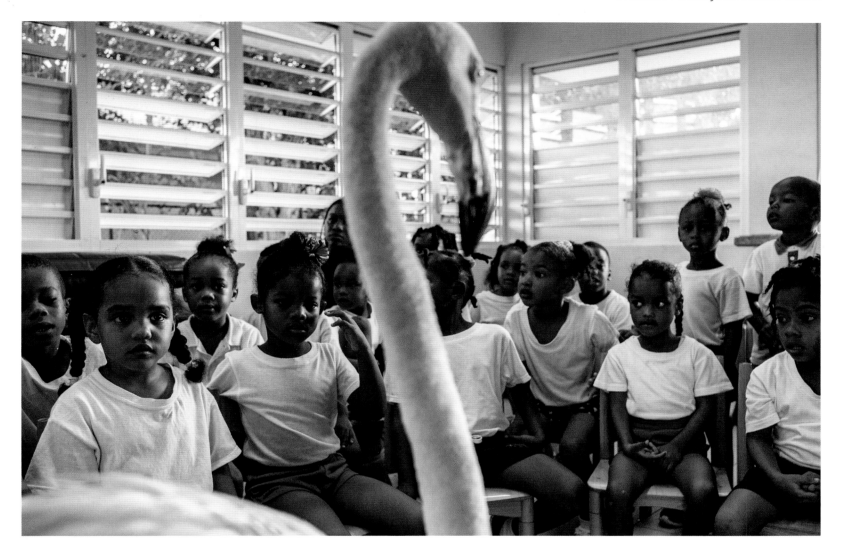

Teacher-bird

As the charity's ambassador, Bob accompanies Odette on regular school visits, such as to this school in a district of Willemstad, where she teaches pupils about conservation issues on Curaçao. By bringing Bob into the classroom, Odette is better able to educate the children about his wild relatives and the need to protect their habitat. Bob also helps teach them not to pester the small colony of flamingos that feed at the nearby Jan Kok salt ponds. The hope is that the children will spread the word among their families and friends and grow up proud of the island's wildlife.

Leica M-P + 35mm f2 lens; 1/125 sec at f6.8; ISO 1600.

Leg-work

Bob causes a stir on his arrival at CBA Television Studios in Curaçao's capital, Willemstad, before his guest appearance on the daily morning talk show. When Odette had asked if she could bring a flamingo on the show, the producers had thought she meant a plastic one and were a bit shocked to see Bob. But it wasn't long before one of the presenters introduced herself, while a colleague posted photos on their social media channels. For Odette such positive media attention helps promote the work of the rehabilitation centre to a wider audience.

Leica M-P + 35mm f2 lens; 1/125 sec at f9.5; ISO 5000.

Animal family

At the end of a long day at her veterinary practice, Odette makes supper, accompanied by Bob and, on her shoulder, Willy, a two-year-old free-flying chestnut-fronted macaw she rescued as a chick. Odette and her son also share their home with nine cats and ten dogs. Bob is unfazed by his housemates.

Leica M10 + 21mm f3.4 lens; 1/45 sec at f5.6; ISO 10,000; Profoto flash.

Rising Star
Portfolio Award

This award seeks to inspire and encourage photographers aged from 18 to 26 and is given for a portfolio of work.

Michel d'Oultremont
BELGIUM

Michel's passion for nature was nurtured in the beautiful surroundings of the Belgian village where he grew up. He started taking pictures seriously when he was 15, and at 25, he has already won a series of awards, including this one in 2014. He turned professional two years ago. 'I try always to photograph animals within their environment, in a way that generates the emotion I feel when I am there, but which also lets the viewer imagine the story.'

Dream duel

As storm clouds gathered over the Ardennes forest in Belgium, Michel hid behind a tree under a camouflage net. It was the best spot for viewing any action on the ridge – a place he knew well – but he needed luck for all the elements to come together. The thrilling sound of two red deer stags, roaring in competition over females, echoed through the trees, but infuriatingly the action was taking place further down the slope. Well matched, neither challenger was giving way, and the contest escalated into a noisy clash of antlers. For years, Michel had wanted to picture this highlight of the rut in the dramatic light of dusk, but the stags were never in quite the right place at the right time. At last, the stags appeared on the ridge, antlers locked, silhouetted. Michel had time to capture the clash – through branches of the tree to create the atmosphere – before the light faded and he had to leave the fighters, still locked in battle.

Canon EOS 5D Mark IV + 400mm f2.8 lens + 2x extender; 1/400 sec at f8; ISO 400; Gitzo tripod + Uniqball head.

Night of the bear

On a mild summer night in the mountains of Risnjak National Park, Croatia, a brown bear emerged from the forest shadows into a small clearing. Crouched under a nearby bush beneath his camouflage net, Michel's plan – inspired by his love of Chinese shadow puppets – was to photograph a bear in its forest environment, backlit with natural light. For a while, the bear remained cloaked in darkness, quietly eating berries and grass (staple foods for brown bears, though they are opportunistic feeders and enjoy a varied, omnivorous diet). Michel's patience was rewarded when the bear raised its head, revealing its classic profile against the soft light. 'I loved being alone with the bear,' he says, a sentiment reflected in his intimate portrait, framed by the branches beyond.

Canon EOS 5D Mark II + 400mm f2.8 lens; 1/8000 sec at f2.8; ISO 500; Gitzo tripod + Uniqball head.

Dawn of the squirrel

It was Michel's fondness for red squirrels that prompted him to lie on the forest floor on a dark winter morning. From beneath his camouflage net, he had his eye on one squirrel in particular. Each morning, it took the same route through a woodland near Michel's home in Brussels. Rather than hibernating, red squirrels spend the winter scurrying around in search of food, relying on stores they have built up in autumn to see them through lean times. To encourage it to pause, Michel used nuts. 'After a few days, it paused exactly where I wanted it to, on a fallen branch,' he says. The squirrel eventually obliged with a side-on stance positioned against the leafy window behind, allowing Michel to take its portrait, edged in gentle dawn light, highlighting its whiskers and distinctive tufted ears.

Canon EOS-1D X Mark II + 400mm f2.8 lens; 1/1600 sec at f3.2; ISO 320.

Silent skirmish

In a winter white-out, two short-eared owls squabble over a mouse caught by the larger one. In Cambrai, northern France, Michel had waited eight days for snow, hoping to use it as a backdrop for a hunting owl (the owl's mottled plumage usually camouflages it against vegetation). But he hadn't expected a clash of neighbours. Skilled hunters, short-eared owls detect their prey – small mammals and sometimes birds – mainly by sound, flying almost silently over open country. As the owls showed off their aerial agility, Michel – shooting from his car – focused on their piercing yellow eyes, boldly framed in black. He got his picture, but the contest had no victor. 'The mouse fell and escaped alive.'

Canon EOS 5D Mark III + 500mm f4 lens; 1/640 sec at f4.5; ISO 1250.

Snow snooze

Michel is passionate about not disturbing his subjects. In the Belgian Ardennes, he spotted a red fox sleeping in the snow near its den. He approached metre by metre, finally crawling so as not to wake it. Isolating his subject with a long lens, blurring the background, Michel created a simple, dreamy portrait – just two black-backed ears and a hint of warm, orange fur, nestled in a cloud of white – a peek into the fox's private world. 'I stayed with him for a sublime 10 minutes,' says Michel. 'He twitched his ears from time to time but never once woke up.'

Canon EOS 5D Mark III + 400mm f2.8 lens; 1/1600 sec at f2.8; ISO 250.

Winter lattice

Out looking for foxes in the snow around Lescheret, Belgium, Michel was drawn to the graphic design of this dead tree. Its dark branches – dusted white by a recent blizzard – stood out against the colourless sky. A solitary carrion crow alighted on one of the lower limbs. Though sometimes forming communal roosts in winter, this corvid is most often found alone or in pairs (which form for life). Carrion crows are smart – both in looks and brains. From a distance, they appear entirely black, but close up, their plumage shimmers with a green and purple gloss. They are known to bury food to eat later and sometimes to drop hard-shelled items from a height to crack them and get at the snacks within. Michel was quick to spot the crow's potential in his picture. He framed it centrally, to give maximum impact to the texture and pattern of branches and create a painterly image of simplicity in black and white.

Canon EOS 5D Mark IV + 400mm f2.8 lens; 1/2500 sec at f4; ISO 400.

The Young Wildlife Photographer of the Year 2018

The Young Wildlife Photographer of the Year 2018 is Skye Meaker – the photographer whose picture has been judged to be the most memorable of all the pictures by photographers aged 17 or under.

Skye Meaker

SOUTH AFRICA

Brought up in South Africa, in a family with a love for nature and photography, Skye has been taking pictures since he was seven years old. Now 15, he has already won prizes for his work and is determined to keep learning and to make wildlife photography his lifelong vocation.

WINNER (15–17 YEARS OLD)

Lounging leopard

Mathoja was dozing when they finally found her, lying along a low branch of a nyala tree. And she continued to doze all the time they were there, unfazed by the vehicle. 'She would sleep for a couple of minutes. Then look around briefly. Then fall back to sleep,' says Skye. Mathoja's home is Botswana's Mashatu Game Reserve, which Skye and his family regularly visit, always hoping to see leopards, though they are notoriously elusive. In Bantu language, Mathoja means 'the one that walks with a limp'. Skye calls her Limpy. She limps because of an injury as a cub, but otherwise she is now a healthy eight-year-old, and she remains the calmest of leopards around vehicles. Though she dozed just metres away from Skye, she blended into the background, the morning light was poor, leaves kept blowing across her face, and her eyes were only ever open briefly, making it hard for Skye to compose the shot he was after. Finally, just as she opened her eyes for a second, the overhead branches moved enough to let in a shaft of light that gave a glint to her eyes, helping him to create his memorable portrait.

Canon EOS-1D X + 500mm f4 lens; 1/80 sec at f4; ISO 1250.

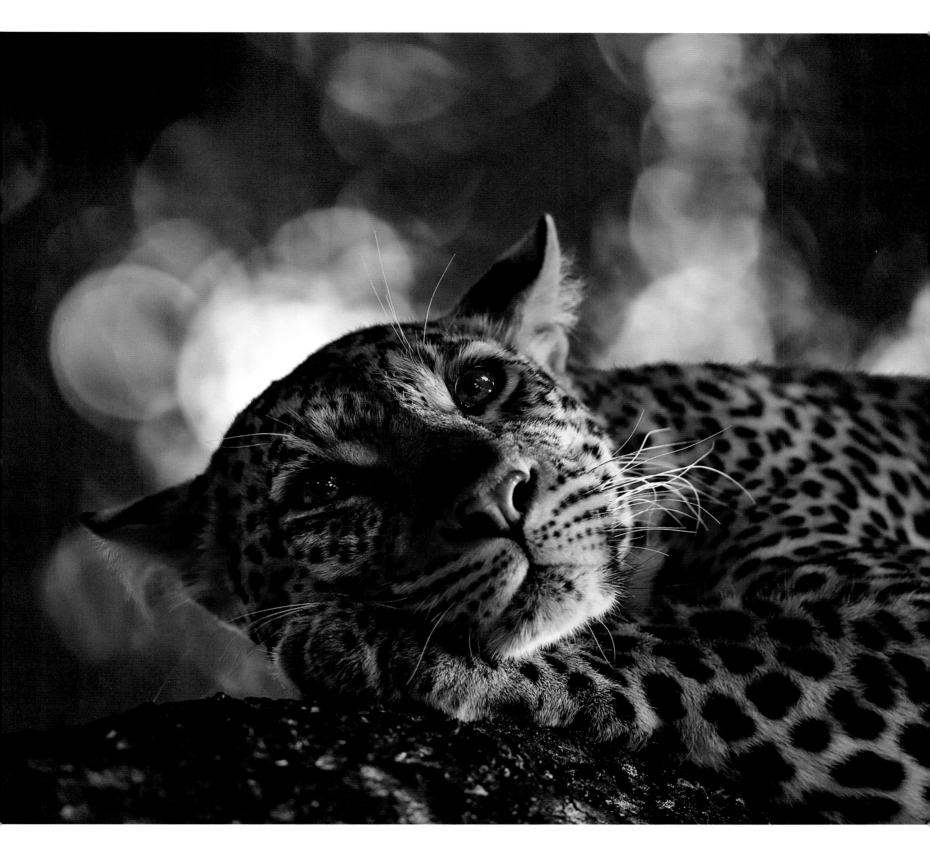

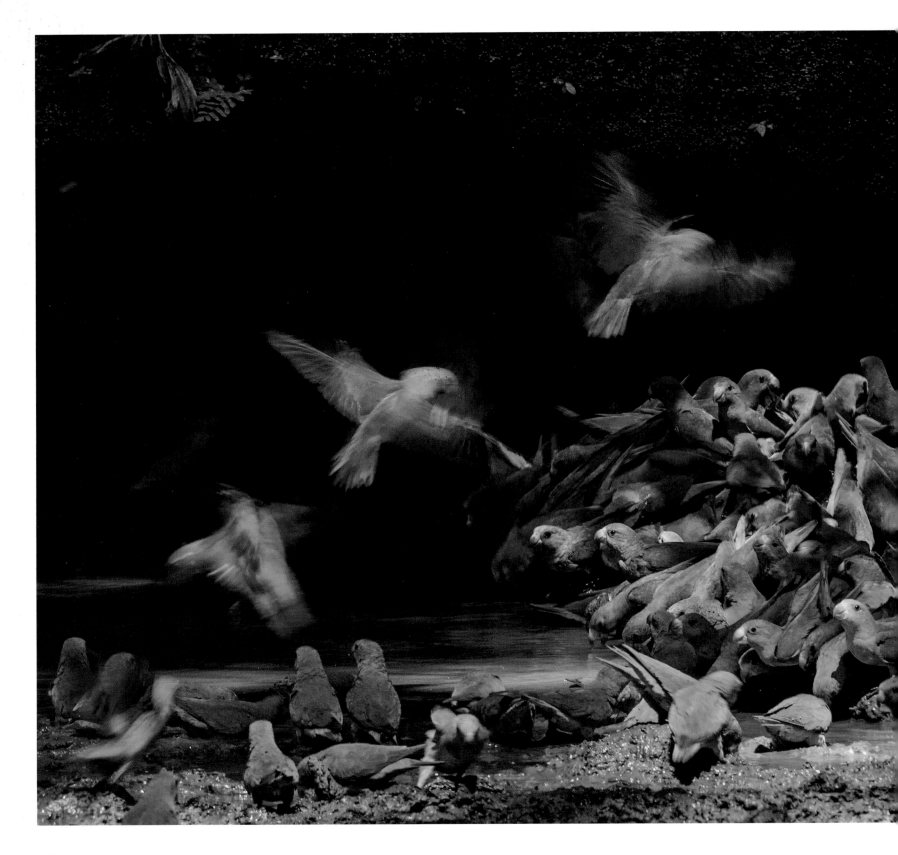

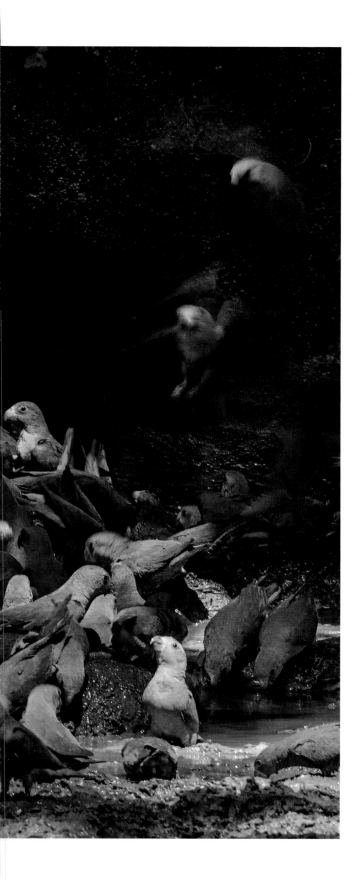

Colour, sound, action
Liron Gertsman
CANADA

It was in a frenzy of colour and deafening crescendo of squawks that the mass of cobalt-winged parakeets finally landed and began to drink the muddy water and grab beakfuls of the wet clay. This was the third day that Liron and a group of young photographers had made the long river and rainforest trek to the hide. And this was the first time he had struck lucky and witnessed the mass descent, though after a five-hour wait. The pool and bank of mineral-rich soil was in Ecuador's Yasuní National Park and Biosphere Reserve. It is believed that the main reason parrots and parakeets come to drink the muddy water here and eat the soil at this and other 'clay licks' in the western Amazon region is to make up for a lack of sodium in their plant-based diets. The birds need this especially during the breeding season when they will be laying eggs. Every day that Liron went, flocks of parakeets would gather noisily in the canopy above and then nervously start to descend towards the forest floor, one branch at a time. But an unexpected noise or the slightest hint of a possible predator would send them up again. On this afternoon, one brave parakeet finally flew to the ground, to be followed immediately by more than 400 others, 'raining down'. By risking a slow shutter speed, Liron added wing colour and a sense of movement and achieved his goal of an image 'that represented the sensation of being there'.

Canon EOS 7D Mark II + 100–400mm f4.5–5.6 lens at 400mm; 1/30 sec at f13; ISO 250; remote release; Milano tripod + ballhead.

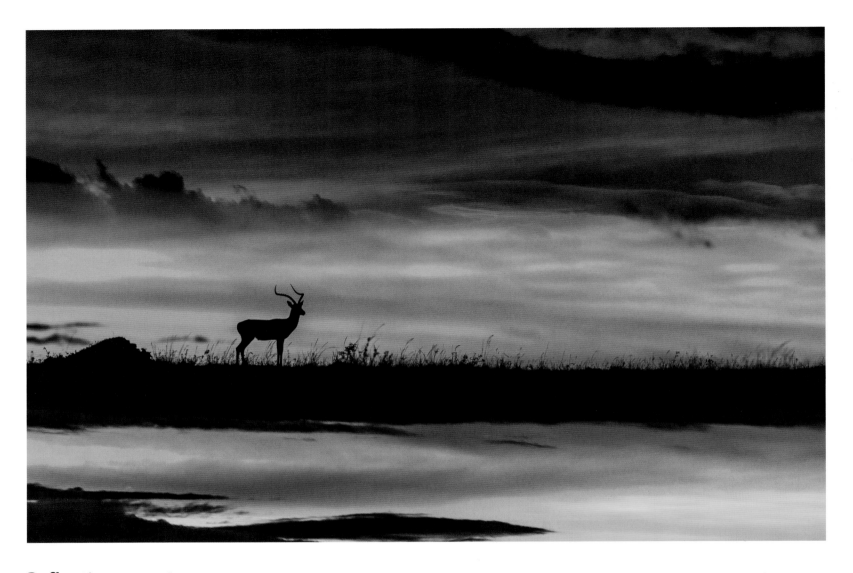

Reflective sunset
Sri Ram Mohan Akshay Valluru
INDIA

Akshay spotted this lone male impala on the horizon as he returned from a
game drive in Kenya's Maasai Mara National Reserve. Drawn to the statuesque
silhouette of the creature, he asked the guide to stop the vehicle just as the
most glorious sunset appeared. Aware that the light would be gone in a second
and that the impala could move, he swiftly put a beanbag on the vehicle's
roof to support and steady his camera and framed his shot. And he then tried
something risky: he decided to use the in-camera multiple-exposure mode
(a technique he had been experimenting with). He captured two frames –
the first of the dramatic dusk sky, and the second of the silhouetted impala.
The camera's in-built function seamlessly merged them, and the result is this
creative illusion of a reflected sky.

Canon EOS-1D X + 500mm f4 lens; 1/100 sec at f4; ISO 400; beanbag.

Overview
Cameron McGeorge
NEW ZEALAND

Since building his first drone, aged 12, Cameron had dreamed of photographing whales from the air. Four years later, when his family went on holiday to Tonga, he had his chance. It was July, the austral winter, when humpback whales arrive to give birth in Tonga's shallow, tropical waters. This Tongan subpopulation has been relatively slow to recover from past intense whaling, especially in its Antarctic feeding grounds. From the island of Foa, Cameron watched through binoculars for whale blows out at sea. Having located a mother and her young calf and their male escort, he waited until they were a kilometre and a half (a mile) offshore and then launched the drone. He used the screen on his remote controller to frame a shot at a moment when the playful calf and its mother's heads were at the surface, 'hoping that I would capture them in focus'. And that's just what he managed to do.

DJI Mavic Pro + 4.73mm lens; 1/25 sec at f2.2; ISO 150.

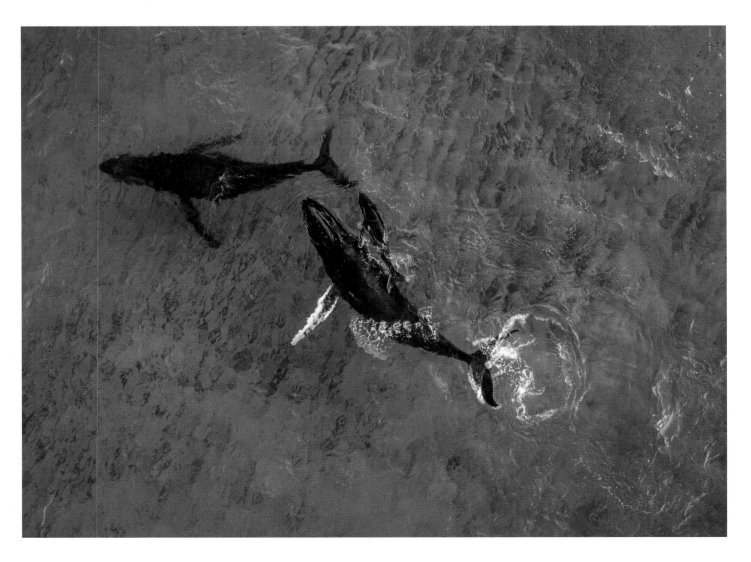

Young Wildlife Photographers: 11–14 years old

Duck of dreams
Carlos Perez Naval

SPAIN

The long-tailed ducks were the most beautiful Carlos had ever seen. In fact, it had been the sea ducks that he most wanted to see when the family planned their holiday to Norway. They were staying on the Varanger Peninsula, on the northern coast of the Barents Sea. But to get close enough to photograph the ducks meant booking a floating hide in the harbour and an early-morning boat, so he and his mother and father would be in the hide before sunrise, before the ducks flew in to feed. It was March, and still bitterly cold, and lying on his belly on the floor of the hide, he felt he might gradually freeze. But the discomfort was worth it. As the light broke, the ducks flew in – eider ducks and long-tailed ducks in their breeding plumage. The only sound was the water lapping against the hide as the ducks dived for fish. He focused on one male that was resting after feeding. An overcast sky muted the dawn light and allowed Carlos to capture the subtle colours of the duck's plumage, and reflected lights from the village added a golden sparkle to the ripples, caught in a perfect frame.

Nikon D7100 + 200–400mm f4 lens at 400mm; 1/320 sec at f4; ISO 1000.

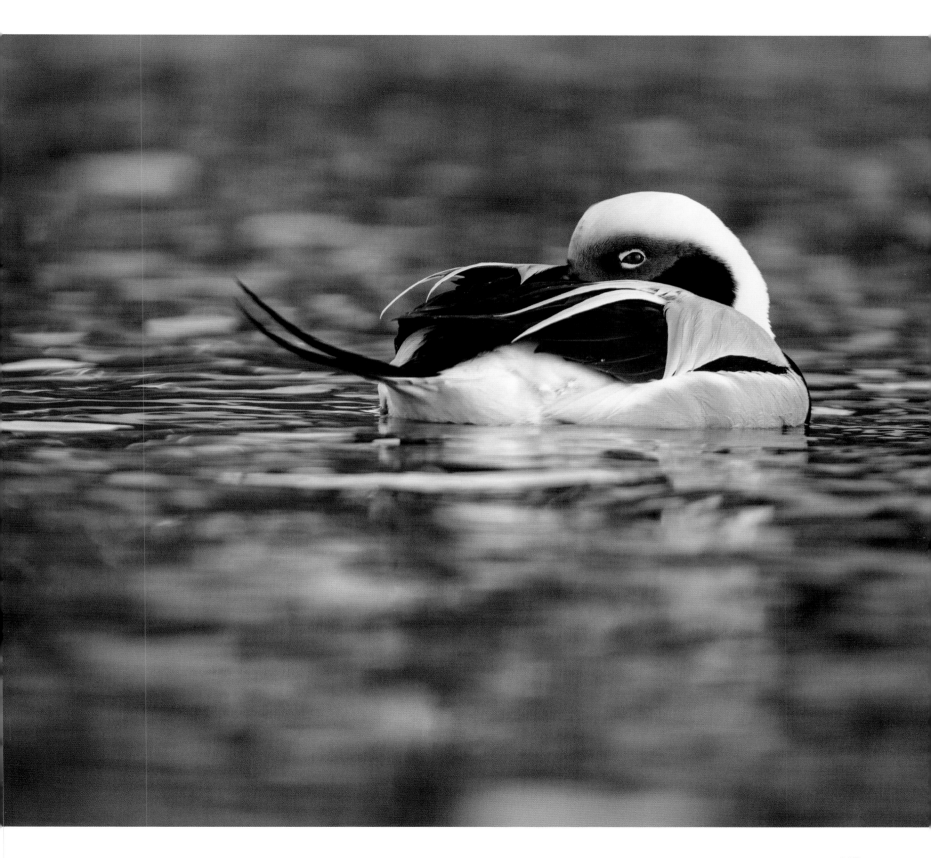

Small world

Carlos Perez Naval

SPAIN

It was the crystal formations in the limestone wall that first caught his eye. Some looked to him like trees, others like oriental drawings. The low wall was in his home town of Calamocha, in Aragon, Spain, and he had walked past it many times. Sometimes he spotted spiders on the stones. Then one day he noticed ladybirds crawling up from out of the grass – and the idea for a picture was born. The challenge was to get down at the right angle to take a close-up. The wall was not much more than knee high, and so he could neither lie down nor stand up. In the end he crouched uncomfortably and waited until a 22-spot ladybird on one of the stones wandered towards the most aesthetically pleasing area of miniature mineral 'trees'. His image, Carlos feels, 'shows the beauty of small and common places and animals when you stop to look closely'.

Nikon D700 + 105mm f2.8 lens; 1/60 sec at f20; ISO 1600.

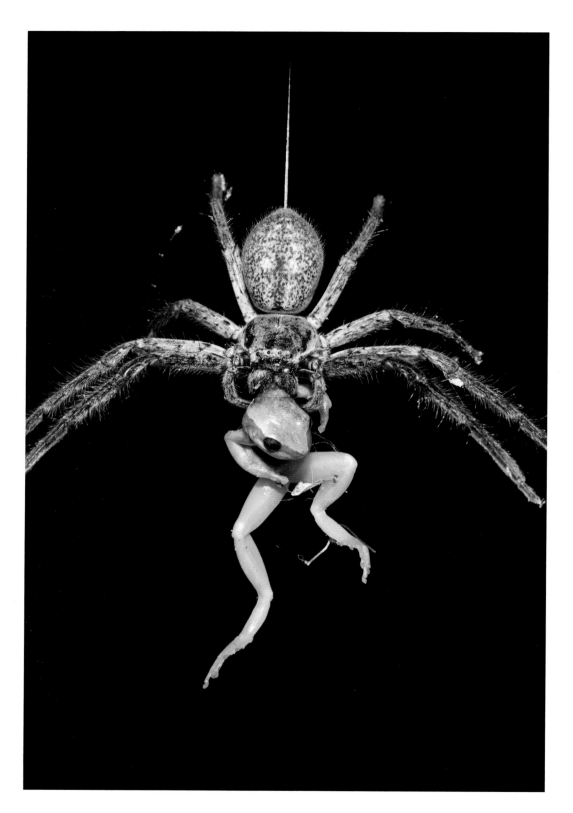

The catch
Robert Irwin
AUSTRALIA

Robert was on a spotlighting wildlife night hunt in a remote swamp on Cape York Peninsula in northern Queensland, Australia, when he came eye to eye with this hand-sized huntsman spider. She was hanging by her silk anchor line from a branch, her fangs still inserted in the now-dead desert tree frog. Approaching slowly so as not to scare the spider and make her drop her catch, he watched as she tried to manipulate the frog with her front legs and pedipalp appendages. Huntsman spiders stalk or ambush their prey at night, usually invertebrates, rather than catch them in webs, and while it is rare for one to take a large frog, they will attempt to catch lizards and even small mammals. The likelihood is that the *Holconia* spider had been knocked off balance by the frog's struggling and had saved herself from crashing to the forest floor by the silk anchor line she had already set. Whether the spider managed to get to a solid feeding perch, fell to the ground or sucked the nutrients out of the frog while suspended, Robert can only wonder, as he eventually had to leave her to it.

Canon EOS-1D X Mark II + 100mm f2.8 lens; 1/250 sec at f13; ISO 160; Speedlight 600EX II RT flash + ST-E3-RT transmitter + diffuser.

The victor

Adam Hakim Hogg

MALAYSIA

When Adam first spotted the Titiwangsa horned tree lizard on the road near his home in the mountains of Pahang, Malaysia, it was in a furious life-and-death battle with a venomous Malaysian jewel centipede. There was a lot of chasing, writhing and thrashing about, and Adam was so fascinated that he completely forgot about his camera and simply watched. Only when the lizard finally overpowered the centipede did Adam think about framing a picture. He jumped into the ditch and crawled towards the lizard for an eye-level portrait of the victor standing over its prize. The species is one of Adam's favourite lizards. But it is also highly sought after by poachers for the pet trade, and Adam and his father do regular anti-poaching walks. So once this individual had finished its meal, Adam made sure it ran back into the safety of the forest.

Lumix GH3 + Canon 70–200mm f2.8 lens + micro 4/3 adaptor; 1/1000 sec; ISO 1600.

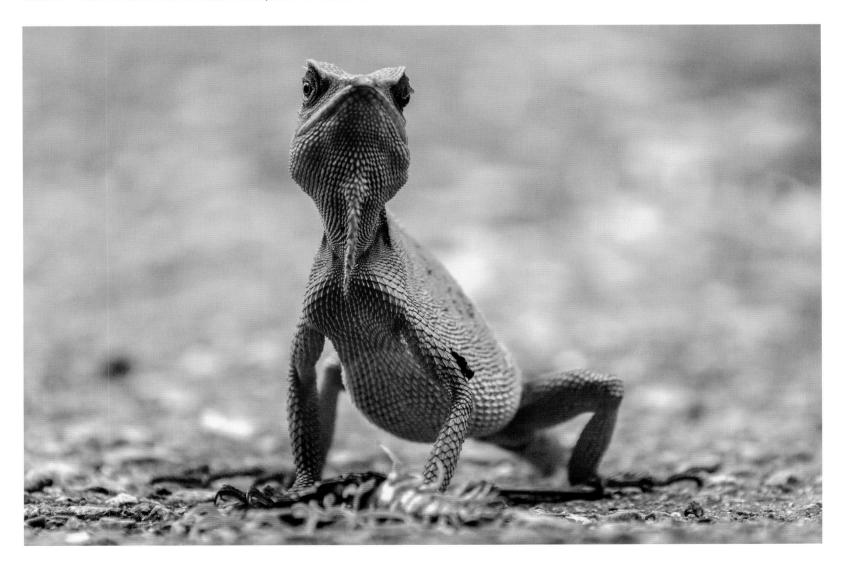

Young Wildlife Photographers:
10 years and under

Pipe owls

Arshdeep Singh

INDIA

Huddled together at the opening of an old waste-pipe, two spotted owlets look straight into Arshdeep's lens. He and his father had been driving out of Kapurthala, a city in the Indian state of Punjab, going on a birding trip, when he saw one of them dive into the pipe. His father didn't believe what he'd seen but stopped the car and backed up. It wasn't long before one of the owlets popped its head out. Guessing this might be a nest site and keen to photograph such an unusual setting, Arshdeep begged to borrow his father's camera and telephoto lens. Using skills accrued from photographing birds since he was six years old, Arshdeep rested the lens on the car's open window and waited. He wasn't at eye level, though. Realizing that if the window was half open, he could place the lens at the right height, he knelt on the seat and waited. It wasn't long before the curious owlet – less than 20 centimetres (8 inches) high – put its head out again, closely followed by the larger female. Framing the pair off-centre, and using a shallow depth of field to isolate them from the building behind, he created a characterful portrait of a species that has adapted to urban life.

Nikon D500 + 500mm f4 lens; 1/1600 sec at f4 (-0.7 e/v); ISO 450.

Displaced displayer

Fred Zacek
ESTONIA

Fred had never seen a wild capercaillie, so when his father discovered a lone male displaying in a nature reserve close to their home in southern Estonia, Fred begged to see it. In spring, male capercaillies gather at traditional 'lekking' sites, often in open woodland areas, take up display territories and, to impress any assembled females, perform energetic competitive displays. Mature males defend the best sites, and young and subdominant males – often high on testosterone – tend to wander away in search of females. With no other capercaillies nearby, this lone male's dominance display – interspersed with running attacks – was aimed at Fred and his father. Here the bird had leapt onto a fallen tree to give himself height. Fanning his tail, he drooped his wings, thrust his head into the air to display his ruffled beard and reflective plumage, and then let out an extraordinary noise that, as Fred recalls, sounded like a gun being loaded and then fired.

Nikon D810 + 105mm f2.8 lens; 1/2500 sec at f2.8; ISO 1600.

Meadow song
Fred Zacek
ESTONIA

In the last rays of the setting sun, a male yellow wagtail is calling from his perch on a stem of cow parsley. Lying in the long grass nearby, listening to the bird's loud repetitive song, was eight-year-old Fred. For three days, along with his sister and father, he had visited the meadow close to their home in Estonia to photograph the breeding birds, which also included larks and whinchats. By the third evening, the birds had become accustomed to the family's presence, but getting close enough for an intimate photograph was not easy. Spotting this male yellow wagtail – his bright yellow chest glowing in the soft evening light – Fred was determined to take a portrait of it singing. Battling stinging nettles and clouds of gnats, he crawled through the tall grass to within shooting range. After a few unsuccessful attempts at anticipating the exact moment when the bird's beak was wide open, he finally got his shot of a yellow wagtail in full song.

Nikon D500 + 300mm f4 lens + 1.4x teleconverter; 1/640 sec at f5.6; ISO 1600.

Index of Photographers

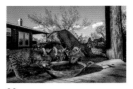

90
Karine Aigner
USA
www.karineaigner.com

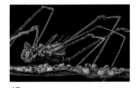

47
Javier Aznar González de Rueda
SPAIN
www.javieraznarphotography.com

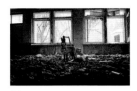

86
Adrian Bliss
UK
www.adrianbliss.co

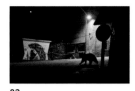

82
Marco Colombo
ITALY
www.calosoma.it

110
Joan de la Malla
SPAIN
www.joandelamalla.com

72
Stefano Baglioni
ITALY
saba7276@gmail.com

102
Theo Bosboom
THE NETHERLANDS
www.theobosboom.nl

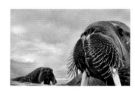

64
Valter Bernardeschi
ITALY
valterbernardeschi@gmail.com
www.ilmiocantolibero.com

26
Chris Brunskill
UK
www.chrisbrunskill.co.uk
Agent
www.gettyimages.com

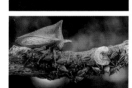

53
Emanuele Biggi
ITALY
www.anura.it

96
Denis Budkov
RUSSIA
www.kamphototour.com

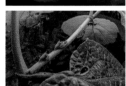

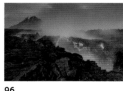

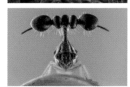

12–19
Javier Aznar González de Rueda
SPAIN
www.javieraznarphotography.com

134–9
Michel d'Oultremont
BELGIUM
www.micheldoultremont.com

128–133
Jasper Doest
THE NETHERLANDS
www.jasperdoest.com

44
Andrés Miguel Domínguez
SPAIN
www.dendrocopos.com

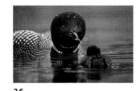

36
Jess Findlay
CANADA
jfindlayphotography@gmail.com
www.jessfindlay.com

142
Liron Gertsman
CANADA
www.lirongertsman.com

50
Marc Graf
AUSTRIA
www.grafmarc.at

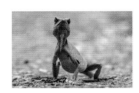

68
Jen Guyton
GERMANY/USA
www.jenguyton.com
Agent
www.naturepl.com

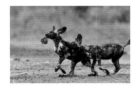

22
Nicholas Dyer
UK
www.nicholasdyer.com

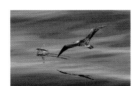

34
Sue Forbes
UK
www.sueforbesphoto.com

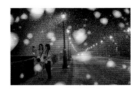

45
Justin Gilligan
AUSTRALIA
www.justingilligan.com

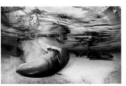

84
Jose Manuel Grandio
SPAIN
www.josemanuelgrandio.com

151
Adam Hakim Hogg
MALAYSIA
adamhakim70d@gmail.com

70
Antonio Fernandez
SPAIN
www.antoniofernandezphoto.com

56
David Gallan
AUSTRALIA
www.greybox73.wixsite.com/davidgallan
www.facebook.com/Understorey-
a-film-on-the-south-east-forest-
campaigns-940034452718427

58
Sergey Gorshkov
RUSSIA
www.gorshkov-photo.com
Agents
www.mindenpictures.com
www.naturepl.com

78, 79
Shane Gross
CANADA
www.shanegross.com

118
Morgan Heim
USA
www.morganheim.com
www.tandemstock.com

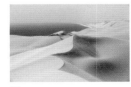

92
Orlando Fernandez Miranda
SPAIN
www.orlandomiranda.com

116
Emily Garthwaite
UK
www.emilygarthwaite.com

25
Tertius A Gous
SOUTH AFRICA
www.tertiusgous.com

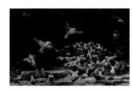

85
Felix Heintzenberg
GERMANY/SWEDEN
www.heintzenberg.com

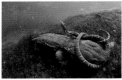

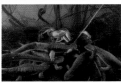

38, 40
David Herasimtschuk
USA
www.davidherasimtschuk.com
www.freshwatersillustrated.org

114
David Higgins
UK
mckeedi@hotmail.com
www.yourshot.nationalgeographic.
com/profile/1001140

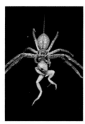

150
Robert Irwin
AUSTRALIA
www.robertirwinphotos.com

113
Britta Jaschinski
GERMANY/UK
www.brittaphotography.com

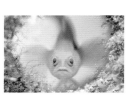

80
Wayne Jones
AUSTRALIA
wjemptiness2@hotmail.com

108
Jayesh Joshi
INDIA
www.trailsofjj.com

95, 98
Georg Kantioler
ITALY
www.kantioler.it

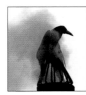

88
Tom Kennedy
IRELAND
5540tomkennedy@gmail.com

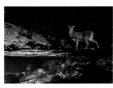

74
Zorica Kovacevic
SERBIA/USA
bebakov@gmail.com
www.zoricakovacevicphotography.com

24
Julius Kramer
GERMANY
www.fokusnatur.de

119
Greg Lecoeur
FRANCE
www.greglecoeur.com

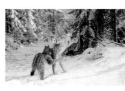

52
Vegard Lødøen
NORWAY
www.vlfoto.no

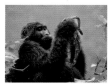

145
Cameron McGeorge
NEW ZEALAND
cmphoto@outlook.co.nz
www.cameron-mcgeorge-photo.
smugmug.com

94, 105
Paul Mckenzie
IRELAND/HONG KONG
www.wildencounters.net

104
David Maitland
UK
david@davidmaitland.com
www.davidmaitland.com

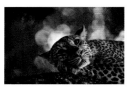

140
Skye Meaker
SOUTH AFRICA
emeaker@webstorm.co.za
www.skyemeaker.com

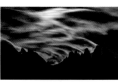

20
Ricardo Núñez Montero
SPAIN
www.ricardonmphotography.com

117
Antonio Olmos
MEXICO/UK
www.antonioolmos.com

28
Thomas P Peschak
GERMANY/SOUTH AFRICA
www.thomaspeschak.com
Agent
www.natgeocreative.com

30
Oliver Richter
GERMANY
www.richter-naturfotografie.de

112
Susan Scott
SOUTH AFRICA
www.susanscott.com

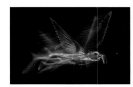

76
Michael Patrick O'Neill
USA
www.mpostock.com

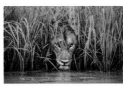

62
Darío Podestá
ARGENTINA
www.dariopodesta.com

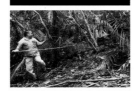

81
Audun Rikardsen
NORWAY
www.audunrikardsen.com

48, 100
Cristobal Serrano
SPAIN
www.cristobalserrano.com

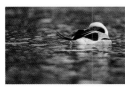

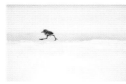

66
Isak Pretorius
SOUTH AFRICA
www.theafricanphotographer.com

54
Emmanuel Rondeau
FRANCE
www.emmanuelrondeau.com

41
Lorenzo Shoubridge
ITALY
www.naturephotography.it

146, 148
Carlos Perez Naval
SPAIN
enavalsu@gmail.com
www.carlospereznaval.wordpress.com

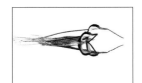

120–7
Alejandro Prieto
MEXICO
www.alejandroprietophotography.com

32
Karen Schuenemann
USA
www.wildernessatheart.com

152
Arshdeep Singh
INDIA
info@arshdeep.in
www.arshdeep.in

144
Sri Ram Mohan Akshay Valluru
INDIA
hymakar1@gmail.com

46
Christian Wappl
AUSTRIA
www.christianwappl.com

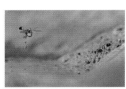

42
Georgina Steytler
AUSTRALIA
www.georginasteytler.com.au

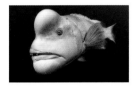

106
Jan van der Greef
THE NETHERLANDS
www.janvandergreef.com

63
Tony Wu
USA
www.tony-wu.com
Agent
www.naturepl.com

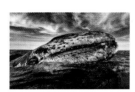

109
Christopher Swann
UK
www.cswannphotography.com

10, 60
Marsel van Oosten
THE NETHERLANDS
www.squiver.com

154, 155
Fred Začek
ESTONIA
sven@looduspilt.ee